MW01098925

The Kiss

The most memorable kisses in history

TECTUM
PUBLISHERS

Content

©2011
Tectum Publishers
Godefriduskaai 22
2000 Antwerp
Belgium
info@tectum.be
+ 32 3 226 66 73
www.tectum.be

ISBN: 978-90-79761-62-3
WD: 2011/9021/02 (125)

Concept and text: Birgit Krols
Design: Gunter Segers
Cover design: Mieke Smalle & Gunter Segers
Photos: Corbis, Getty-Images, Bridgeman Art
Library, British Film Institute, Cinematek-Brussels

All rights reserved.
No part of this may be reproduced in any form,
by print, photo print, microfilm or any other means
without written permission from the publisher.

Printed in Slovenia.

All facts in this book have been researched with
utmost precision. However, we can neither be held
responsible for any inaccuracies nor for subsequent
loss or damage arising.

The Film Kiss

The Real Life Kiss

The Artistic Kiss

The kiss ...
the shadow
of our soul

Introduction

"Kiss, noun; a touch or caress with the lips."
This is the straightforward, no nonsense description in the Oxford dictionary. It is immediately clear that dictionaries know everything about words but have absolutely no idea about kissing. Surely a kiss is more than just a 'touch with the lips'! How about a passionate kiss that makes your head spin, your stomach explode with butterflies and your heart skip a beat? A motherly 'kiss-it-better' kiss that works without fail? And a kiss goodbye that turns your world upside down?

Let's take a closer look at 'philematology', or in layman terms, the science of the kiss. According to *the lucky few* who specialise in the subject, kissing is a basic need to which more than 90% of the population devote themselves. Based on a life's worth, starting at an average age of 14, this results in 20,160 minutes (or 336 hours) of kissing. A good old snog will give a work-out to all 34 face muscles, as well as 112 other muscles, is good for your teeth, makes your eyes shine and works wonders for your skin. As with meditation, it enriches your consciousness, takes away fear and releases tension in the brain (it is even a remedy for headaches!). Kissing releases hormones that stimulate lust, encourages the feeling of togetherness between two people and reduces stress. The chemical processes that take place during the first kiss may even be crucial in the selection of a partner: that well-known 'spark' depends largely on the compatibility of the immune system of the kissers.

All these facts, however interesting they may be, still do not reveal the essence of the kiss. This simple gesture, comprising of so many feelings, seems indescribable. The French writer Guy de Maupassant once said that "a kiss is the most wonderful way to be silent whilst saying it all". He hit the nail on the head there. However silent a kiss may be, it tells its own tale. A passionate embrace is infused by passion, a romantic caress sprouts from love, a motherly kiss is a sign of affection, a you-may-kiss-the-bride kiss promises faithfulness, a farewell smooch reveals sadness and a friendly peck is the nicest way to greet each other. However, a kiss may also convey betrayal, imply death or express gratitude, peace, obedience, loyalty and respect.

Perhaps it is one of those things in life you simply cannot comprehend but which unquestionably has to be enjoyed.
And as it happens, that is exactly what this book is about.
The kiss. In all its simplicity and glory.
The act of lips talking without saying a word.

"A kiss can be a comma, a question mark or an exclamation point. That's basic spelling that every woman ought to know."

Mistinguett (Jeanne Bourgeois) (1875-1956), French singer/actress

7

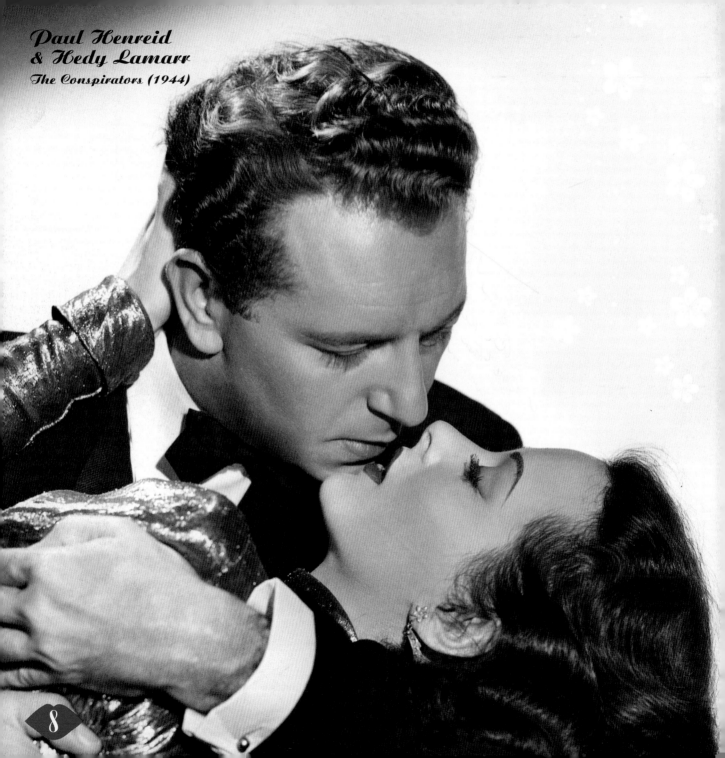

Paul Henreid
& Hedy Lamarr
The Conspirators (1944)

The Film
kiss

The first kiss on film
The Kiss (1896)

The very first kiss on film was recorded in 1896 by inventor. Thomas Edison: he filmed Broadway actors John C. Rice and May Irwin during a love scene in the play *The Widow Jones*. This twenty second shot was hardly sexy: the actors were of retirement age, unattractive and clearly had a different definition of kissing as they continued talking during their smooch. Nevertheless, *The Kiss* soon became the most popular Vitascope film ever, much to the disgust of the church.

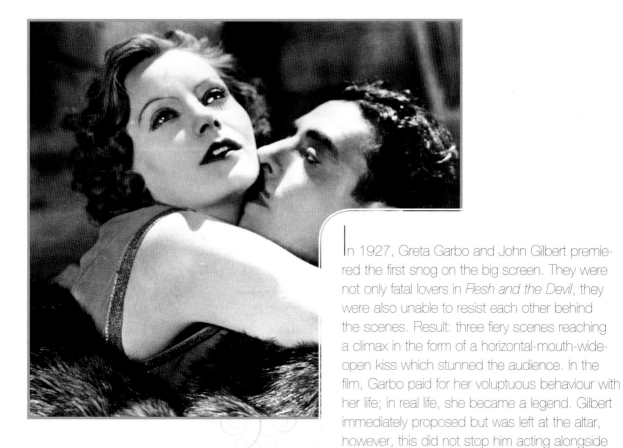

In 1927, Greta Garbo and John Gilbert premiered the first snog on the big screen. They were not only fatal lovers in *Flesh and the Devil*, they were also unable to resist each other behind the scenes. Result: three fiery scenes reaching a climax in the form of a horizontal-mouth-wide-open kiss which stunned the audience. In the film, Garbo paid for her voluptuous behaviour with her life; in real life, she became a legend. Gilbert immediately proposed but was left at the altar, however, this did not stop him acting alongside her in other films bubbling with passion and yearning.

The first snog on film
Flesh and the Devil (1927)

First kisses

My Girl (1991)

Your first kiss is a memorable experience announcing the start of puberty. An event which the film industry loves to play on. It was the adorable *alien E.T.* who inspired his human friend Elliot to kiss his classmate during a biology lesson; eleven year old child film star Macaulay Culkin got his first smacker in the film *My Girl* and a very young Sophie Marceau takes her first steps when it comes to love in the French cult film *La Boum*, including her first party, first boyfriend and first kiss.

E.T. (1982)

La Boum (1984)

13

The longest kiss in film history

For 72 years, record holders for the longest kiss in film history were the Indian couple Devika Rani and Himanshu Rai. In the 1933 Bollywood film *Karma*, Rani kept the audience entertained for 4 minutes of lip gymnastics whilst Rai acted convincingly unconscious. For 64 years, the US record was in name of Regis Toomey and Jane Wyman who managed to stretch out their embrace for 3 minutes and 5 seconds in the 1941 film *You're in the Army Now*. Both records were beaten in 2005 when Stephanie Sherrin and Gregory Smith dragged out their tongue sandwich for 5 minutes and 57 seconds during the credits of *Kids in America*.

Kids in America *(2005)*

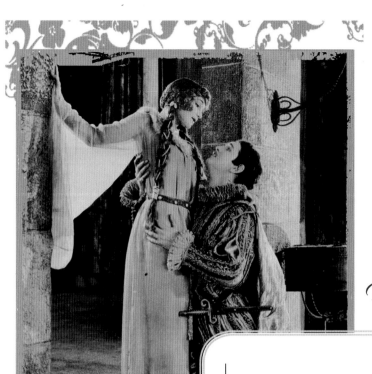

Don Juan (1926)

If you think that there is more smooching in films these days than say, 80 years ago, you will be in for a surprise. The film with the most kisses turns out to date back to 1926. In *Don Juan*, John Barrymore kissed his co-stars Mary Astor and Estelle Taylor an impressive 127 times. Unable to resist, the rascal planted his lips on several other ladies, bringing the total to 191 in the 167 minute long film. That is an average of one kiss every 53 seconds. There can't have been that many lines left for Barrymore...

The film with the most kisses

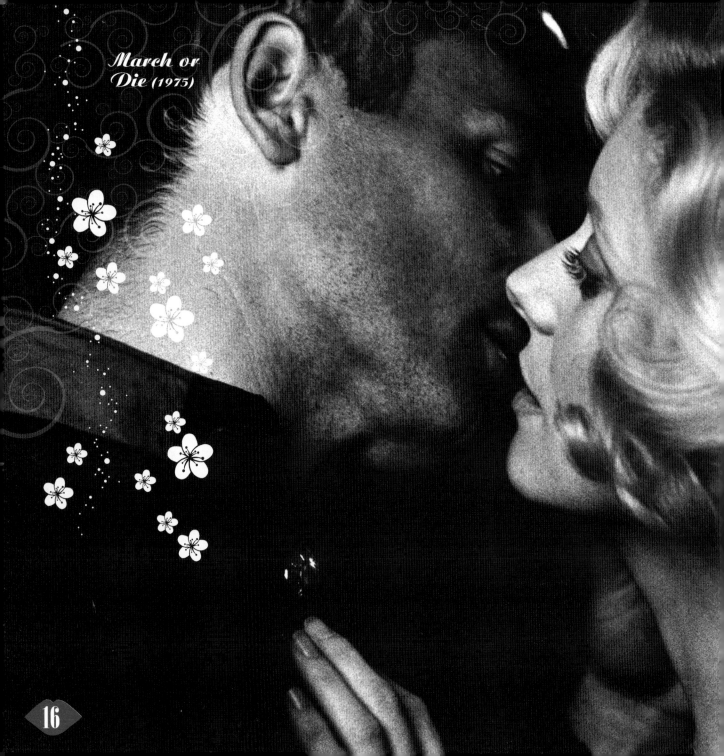

"A man snatches the first kiss, pleads for the second, demands the third, takes the fourth, accepts the fifth - and endures all the rest."

Helen Rowland (1875-1950), American journalist and comedian

Magical kisses

The Princess and the Frog (2009)

Everyone knows that some kisses can make you wobbly on your feet and let a million butterflies hatch in your stomach. However, some kisses have even more magical powers! The right smackers are able to wake up princesses from the sleeping spell they are under (think *Snow White*, *Sleeping Beauty* and *Enchanted*), change frogs into princes and girls into frogs (*The Princess and the Frog*) and rescue mermaids from the jaws of soapy sea witches (*The Little Mermaid*).

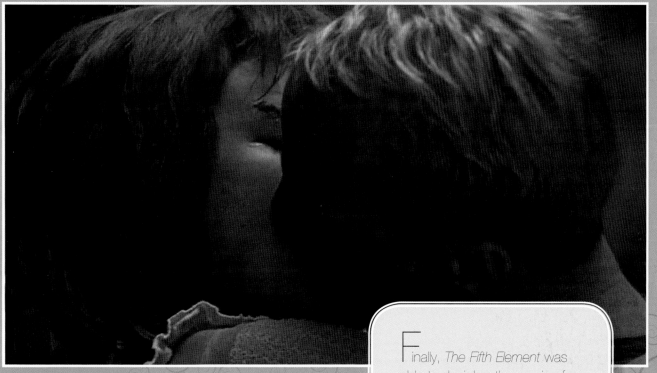

The Fifth Element (1997)

Finally, *The Fifth Element* was able to decipher the magic of a kiss: aside from the classic elements Earth, Water, Fire and Air, there was a fifth element Love. So in order to save the world, taxi driver Dallas simply had to inform the pretty Leelo that he fancied the pants off her and top it off with a proper smooch. What a film!

Gay kisses

Wings (1927)

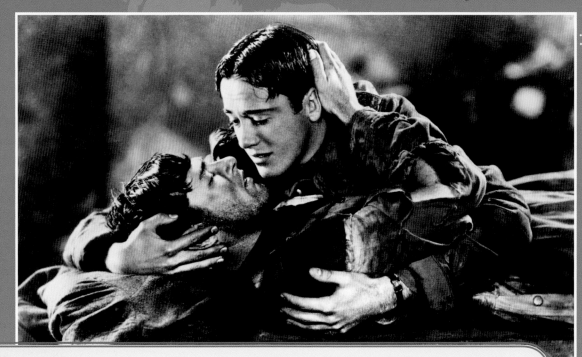

The first kiss on screen between two men took place as early as 1927. In the film *Wings*, soldier John "Jack" Powell had a serious lip embrace with his dying friend David Armstrong. The film must have made quite an impression as it won the very first Oscar for Best Film. The first proper gay kiss on screen in 1971 caused a great deal more of controversy. In *Sunday Bloody Sunday*, a business woman, a Jewish doctor and a bisexual artist engage in a bizarre love triangle. All is well until Murray Head and Peter Finch kiss each other full on, on the mouth. The audience was disgusted and the film flopped.

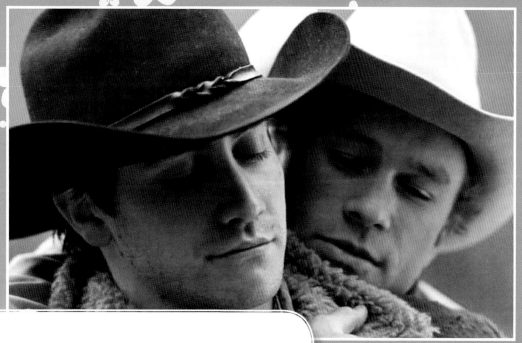

These days we are more open-minded, but it wasn't until 2005 that the very first gay blockbuster screened in cinemas. All critics predicted that Ang Lee's film about a pair of loved up cowboys who had been hiding their relationship for twenty years was doomed. The world was baffled when the director delivered a box-office hit and won three Oscars for the effort. The rough, tragic kiss between Heath Ledger and Jake Gyllenhaal that symbolises happiness after an emotional reunion and wretchedness as they cannot openly declare their love for one another, is unquestionably the 'gay kiss of the century'.

Brokeback Mountain (2005)

Lesbian kisses

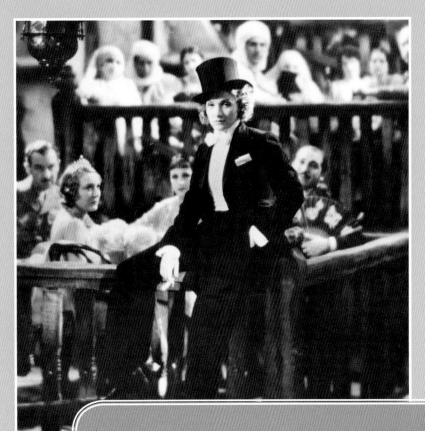

Morocco
(1930)

In 1930, German Marlene Dietrich shocked and sent her new American audience into ecstasies with the film *Morocco*. Not only did she waltz around in a sexy, tight-fitting dinner jacket with top hat, she also unashamedly kissed another woman. The cunning bisexual actress, who had suggested the kiss herself, made sure that censoring was not an option: immediately before she kissed the woman, she took one of her flowers and after kissing her, she threw it to legionnaire Gary Cooper. If the kiss had been axed, the flower would have appeared out of nowhere.

Mädchen in Uniform (1931)

The first lesbian film, the 1931 German *Mädchen in Uniform*, tells us the story of boarding schoolgirl Manuela who falls in love with her teacher Elisabeth von Bemburg, which results in extra special (though still rather chaste) good-night kisses. However, it is the first lesbian TV kiss that received all the attention when in 1991, in *L.A. Law*, the world witnessed sparks flying between the lips of lawyers C.J. Lamb and Abby Perkins. Twenty years on, it is clear that this was a stunt to improve ratings. Numerous long-running series copied the idea so that the term 'lesbian kiss episode' soon became a well-known phenomenon in TV land.

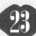

The Lady and the Tramp *(1955)*

Strange kissers

In the category 'kisses that are not erotic but nevertheless have an effect on us'. The moving 'spark' between robot *Wall-E* and his ultra-modern girlfriend Eve when he shows her the plant that provides proof that life on earth is possible again. The spontaneous spaghetti kiss between *Lady and the Tramp* during a candlelit dinner behind Tony's Italian restaurant to the strains of *Bella Notte*. The sweet alien kiss of spring chicken Drew Barrymore in *E.T., The Extra-Terrestrial.*

Wall-E (2006)

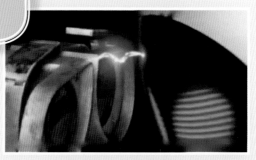

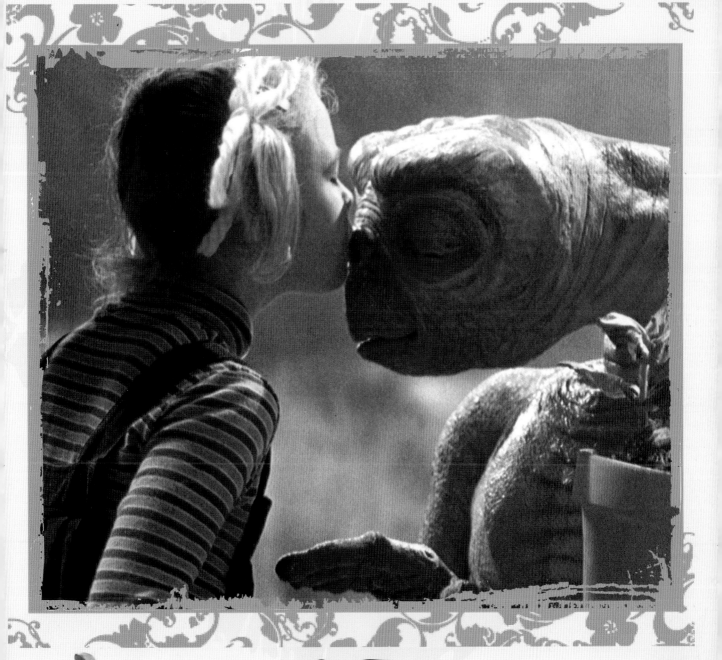

E.T. *(1982)*

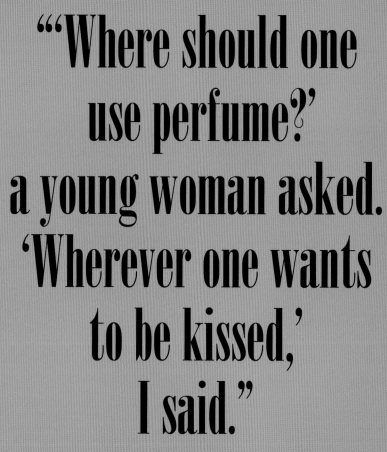

"'Where should one use perfume?' a young woman asked. 'Wherever one wants to be kissed,' I said."

Coco Chanel (1883-1971), French fashion designer

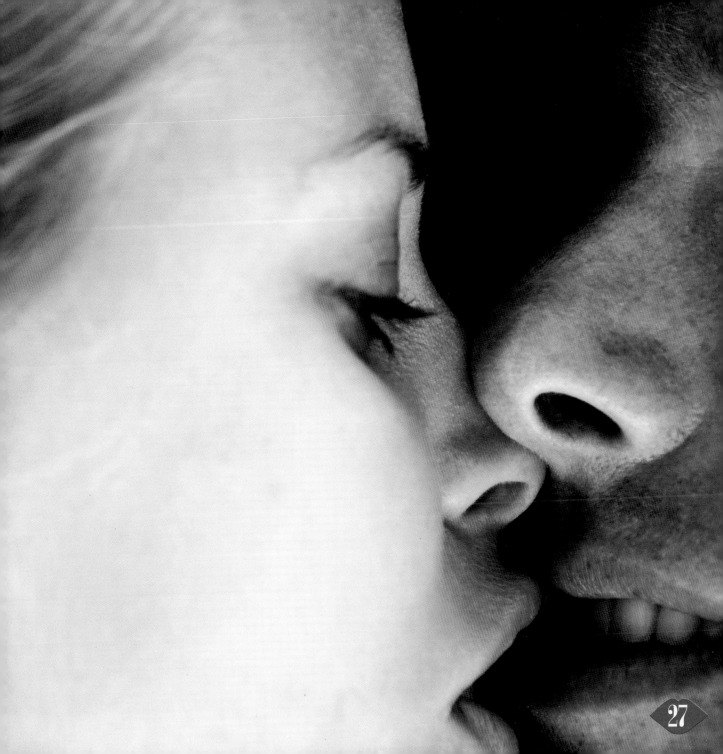

27

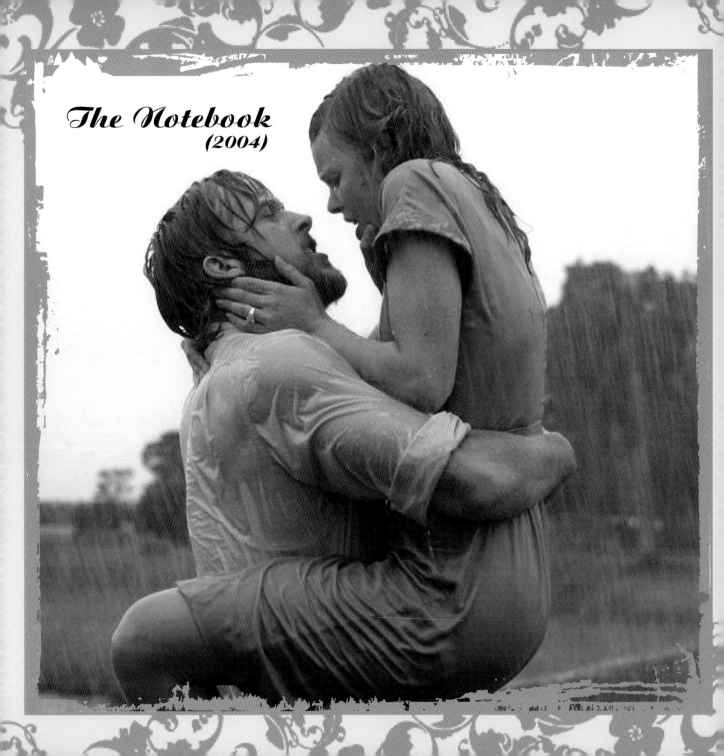

The Notebook
(2004)

The kiss in the rain

Forget candlelight, poetry, lovey-dovey music or fancy dinners; when it comes to romance, rain is the ultimate ingredient. Unexpressed emotions build up like thunderclouds that explode in a storm of outpourings and embraces, and all that in soaking clothes that stick rather tightly to the skin. Noah and Allie from *The Notebook* are made for each other and do not let their unapproving parents, seven lost years and an engagement to someone else come in between - definitely not when the flood gates open. It is the rough mixture of passion and pain, regret and anger that makes this undeniably the most stormy rain kiss in film history.

Australia
(2008)

In *Australia*, widow Lady Sarah cannot resist the charm offensive of a rough cowboy, especially when he looks like Hugh Jackman. The rain makes the attraction even more elementary.

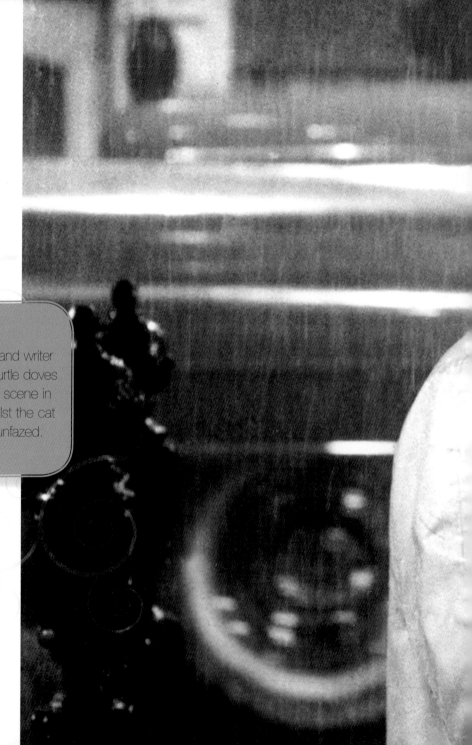

Callgirl Holly Golightly and writer Paul Varjak play kissing turtle doves in the rain during the final scene in *Breakfast at Tiffany's*, whilst the cat they are holding seems unfazed.

Breakfast at Tiffany's
(1961)

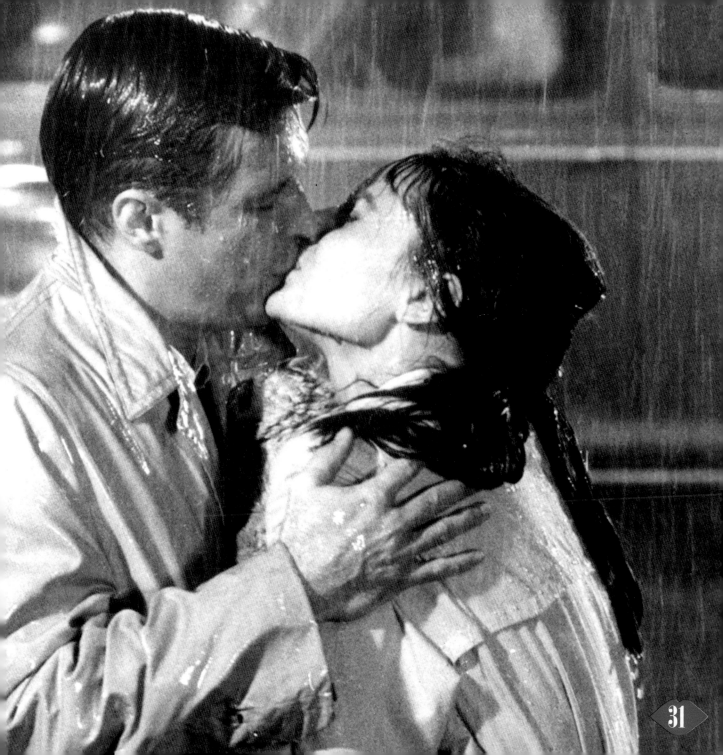

The wet kiss

From Here to Eternity (1953)

If kissing in the rain is the ultimate in romance, smooching under water must be the pinnacle of sensuality. There are numerous films with squelchy kisses but only a few of those have made it into film history. For example, Burt Lancaster and Deborah Kerr's kiss when rolling in the surf in *From Here to Eternity*. It may date back to 1953 but - thanks to iconic posters - it is still vividly remembered by all.

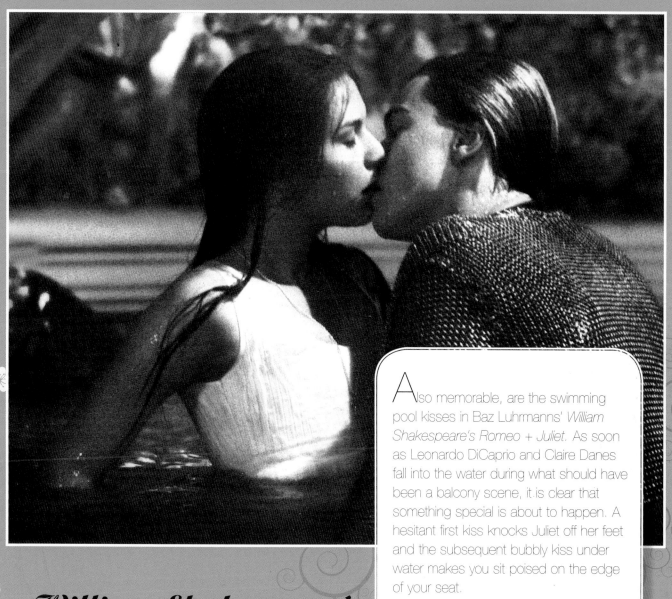

Also memorable, are the swimming pool kisses in Baz Luhrmanns' *William Shakespeare's Romeo + Juliet.* As soon as Leonardo DiCaprio and Claire Danes fall into the water during what should have been a balcony scene, it is clear that something special is about to happen. A hesitant first kiss knocks Juliet off her feet and the subsequent bubbly kiss under water makes you sit poised on the edge of your seat.

William Shakespeare's Romeo + Juliet (1996)

The kiss of death
The Godfather 2 (1974)

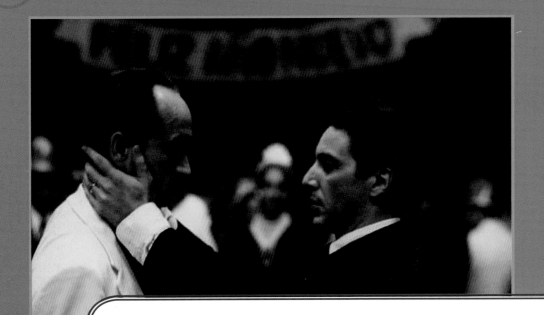

If you have seen *The Godfather* trilogy, you will remember this scene vividly. Godfather Michael Corleone finds out that his only surviving brother Fredo is behind the assault on his life. During a New Year's eve party in Havana, he grabs him by the neck, kisses him on the mouth and utters emotionally: "I know it was you Fredo. You have broken my heart." This scene is particularly powerful when you know that the Kiss of Death is given by the Mafia to people who are about to die in a rather unnatural way. Shortly after, Fredo was found swimming in between the fish.

A loner who breaks into uninhabited houses as a hobby meets a sad woman who is trapped in a violent marriage. They find love in each other that defies all laws of nature. The South Korean film *3-Iron* is a nearly silent tribute to love with the elegance of a fairytale. Tae-Suk masters moving like a ghost to the extent that he is able to move in with Sun-hwa and her husband without him knowing. The ultimate goose bumps moment is the scene where she falls into the arms of her husband and manages, in one smooth movement, to kiss her lover over his shoulders. Dream or reality? Either way, a truly amazing film.

The metaphysical kiss

3-Iron *(2004)*

"*I would rather have had one breath of her hair, one kiss from her mouth, one touch of her hand, than eternity without it. One.*"

Nicholas Cage in *City of Angels* (1998)

The adulterous kiss

In *Facing Windows (La Finestra di Fronte)*, Giovanna is annoyed by the passiveness of her husband Filippo. She projects her unfulfilled desires and unrealised dreams onto her neighbour on which she spies from her window. Soon after they meet, it is clear that Lorenzo has had the hots for her even longer. The sexual tension mounts when their friendship ends in an impassioned kiss on a bench in the park and Giovanna is faced with the biggest dilemma.

Facing Windows (2003)

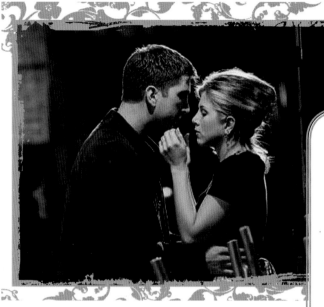

Friends (1995)

The kiss everyone was waiting for

When the second series of *Friends* was first aired, everyone was glued to their screens. After 24 episodes of Ross tiptoeing around Rachel like a lovesick puppy, there were finally some mutual feelings in the series' finale. However, things weren't that easy as an unsuspecting Ross had managed to find himself a new girlfriend when away on business. In the seventh episode of series two, *The One Where Ross Finds Out,* he blames Rachel, after hearing her drunken confession on his answering machine, for disturbing his perfect new life and slams the doors of Central Perk behind him. Seconds later, he returns and - after a sweet embarrassing moment during which Rachel seems iunable to open the door again - their lips finally meet. A kiss that made many viewers tremble on their knees.

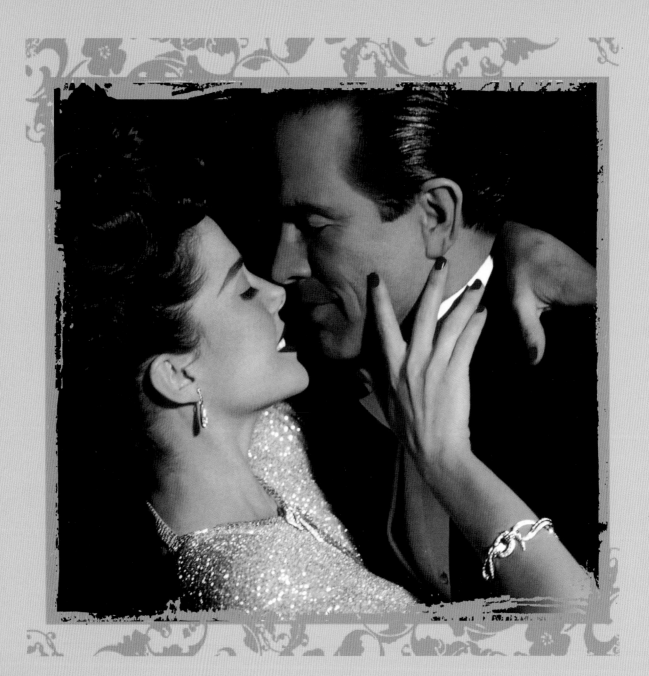

The shadow kiss

One of the most beautiful kisses on screen is unquestionably the one between actress Virginia and gangster Bugsy Siegel in *Bugsy*. The cat and mouse game starts when she enters his house and the camera follows them in one continuous shot through the house into his private film studio. "Do you want to kiss me as much as I want to kiss you?", he asks her, to which she whispers back: "How do you know I want to kiss you at all?". He knows. We all know. Yet the climax still takes your breath away when you see their shadows appear behind the screen, him grabbing her, she making a feeble attempt of hitting him and then, finally, the passionate kiss.

Virginia: "Do you always talk so much before you do it?"

Bugsy (1991)

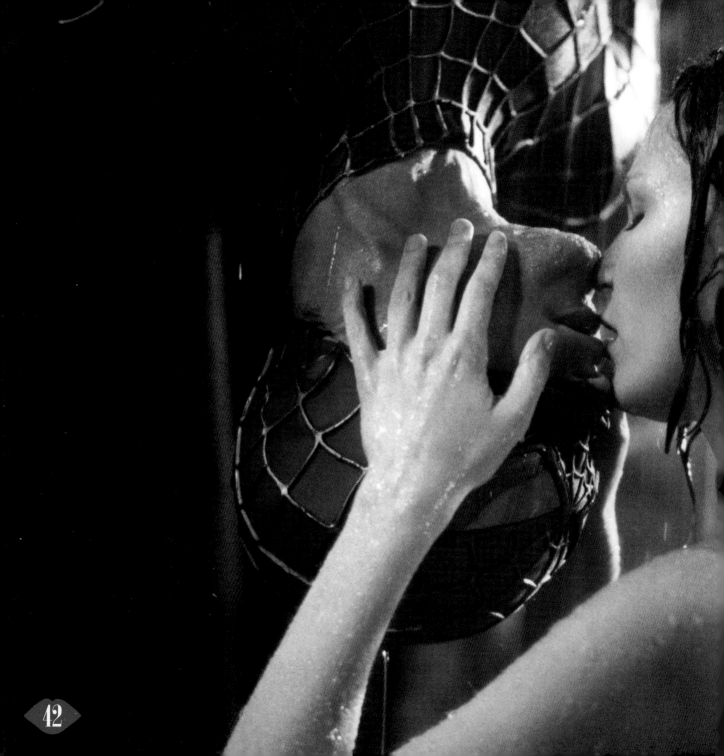

Naturally superheroes have a slightly different approach to the average man on the street and Spiderman is no exception. When he rescues Mary Jane for the second time from the jaws of corrupt gangsters, she insists on thanking him. Surely there is no better way for a lady to say thank you than by kissing her lifesaver. The fact that he is hanging upside down in the pouring rain is a minor detail for actrice Kirsten Dunst who removes his mask up to his nose. The upside down kiss immediately went down in history even though it wasn't all that comfortable according to Tobey Maguire: "I was hanging upside down, there was rain pouring up or down my nose. I couldn't breathe and I was gasping for breath out of the corner of Kirsten's mouth - poor girl I was giving her mouth to mouth rather than kissing her." So *Don't try this at home* (unless perhaps when there is no rain involved).

The upside down kiss
Spiderman
(2002)

The announced kiss

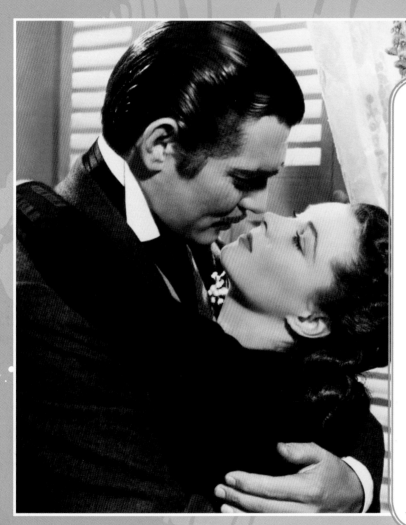

In *Gone with the Wind* Rhett Butler and Scarlett O'Hara play a tough game of hard-to-get which leads to some temptuous love scenes. At first, Rhett the rogue turns down the belle of the county: "No, I don't think I will kiss you, although you need kissing, badly. That's what's wrong with you. You should be kissed and often, and by someone who knows how." It is not until they flee Atlanta that he finally kisses her for the first time - followed by a slap from her. After the funeral of her second husband, he proposes in amusement that she ought to find a man of the right age, who knows how to treat women. Unable to resist him any further, a big smacker of a kiss follows.

Gone with the Wind (1939)

Bridget Jones (2001)

The kiss in the snow

After a desperate search for true love, antihero Bridget Jones finally gets hooked on Mark Darcy. But just as he is about to kiss her, she decides that this is a good time to change into those silly little pants. Whilst she is in the bathroom, Mark finds her diary which contains endless pages of her ranting on about what a loser he is. He leaves and Bridget can't think of anything better than to run after him in the snow, wearing nothing more than some pants with leopard print, a top, a cardigan and trainers. When she finally finds him, he walks out of a stationary shop with a new diary, so she can start a clean slate. The much anticipated kiss that follows is even more sweet.

Bridget: "Wait a minute... Nice boys don't kiss like that."
Mark: "Oh yes they fucking do."

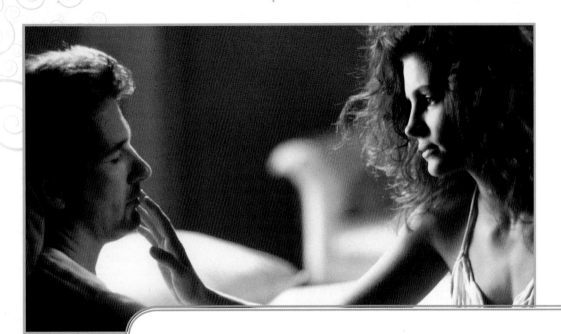

When millionaire Edward meets prostitute Vivian, she immediately tells him she will do anything - aside from kissing. A rule that most prostitutes stick to as kissing is often more intimate and triggers more emotions than having sex. But after Edward has taken her out for an unforgettable night at the opera, she is unable to resist. Asleep on the bed, she carefully bends over him and presses her lips onto his. Naturally, he wakes up just in time to join in... which makes the *Pretty Woman* audience melt like butter on toast.

The unexpected kiss
Pretty Woman (1990)

"A kiss is a lovely trick designed by nature to stop speech when words become superfluous."

Ingrid Bergman (1915-1982), Swedish actress

47

Nuovo Cinema Paradiso (1988)

Films without kisses

Imagine a world without any film kisses. This is what happened in the Sicilian village Giancaldo, thanks to a priest who insisted that all suggestive scenes were to be cut out of films. In *Nuovo Cinema Paradiso*, little Toto is fascinated by the cinema that Alfredo keeps a tight hold over. He would like to pursue a career as director but gets sidetracked when he falls in love (resulting in a fantastic kissing scene in the rain). When the romance ends, he follows Alfredo's advice and focuses on his ambition. As a successful director, he finds out that Alfredo was not only behind his biggest dream but also his greatest loss: it was him who incited the love of his life to leave Toto so that he could follow his dream. As a bittersweet peace offering, he is presented with a film that shows every love scene that was ever cut out, like one enormous love feast.

The first time a black and a white character kissed on TV, all hell broke loose. Although Nancy Sinatra and Sammy Davis Jr. had made a first move in *Movin' with Nancy* in 1967, it was William Shatner and Nichelle Nichols who got the full blast. Oh yes, it was captain James T. Kirk of Star Trek who boldly went where no man had gone before and gave his lieutenant Uhura a proper snog. Granted, the man had been under the influence of alien telekinesis, however, the result remained the same. NBC had demanded two versions of the scene to be filmed: one with and one without the kiss. Unfortunately, Shatner and Nichols managed to ruin every single take of the non-kissing version and there was only one option left...

The first interracial kiss
Star Trek *(1968)*

The vampire kiss

Never before had there been such hype amongst girls and women than *Twilight*, the bestseller series from Stephenie Meyer about teenage girl Bella Swan and vampire Edward Cullen. When news spread that the books would be adapted for the screen, *Twihard* fans all over the world couldn't wait to see the first intimate scenes. Kristen Stewart and Robert Pattinson did not disappoint: their smouldering kiss in Bella's bedroom was a roaring success. From Edward climbing in through the window, him whispering "I just want to try one thing, be very still" to the initially hesitant, though soon more passionate kiss, and his painful retreat, muttering "I can never lose control with you." That he stayed to see her fall asleep with her head on his muscular chest was simply the icing on the cake.

Twilight
(2008)

Edward: "I'm stronger than I thought."
Bella: "I wish I could say the same."

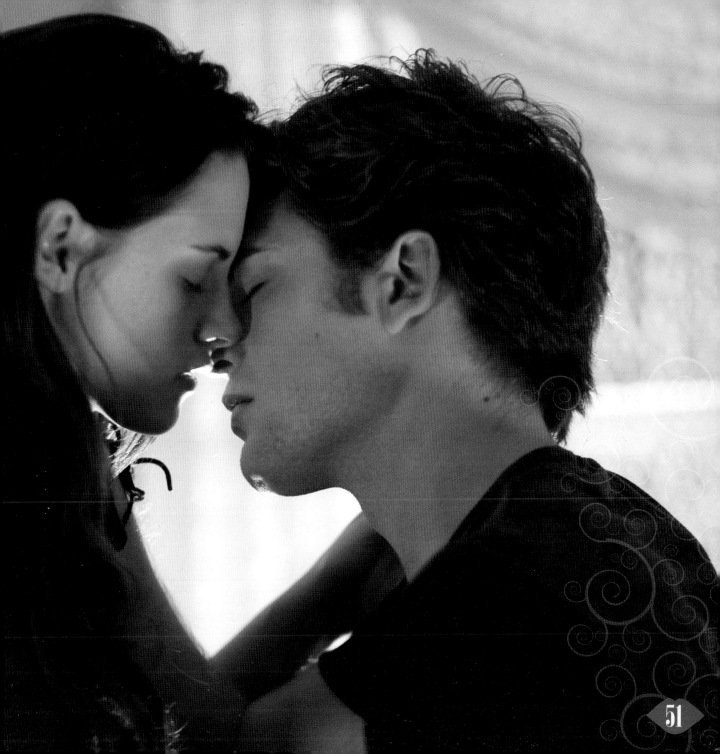

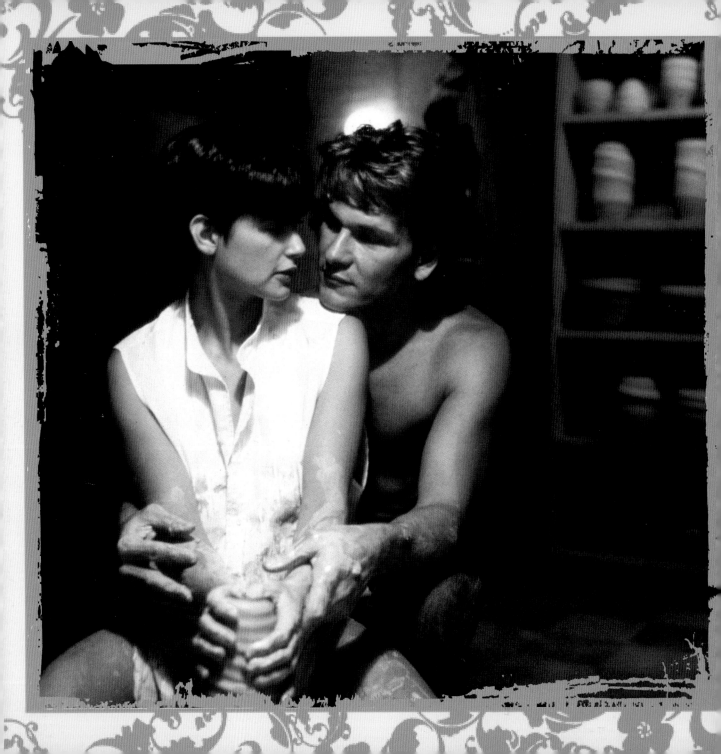

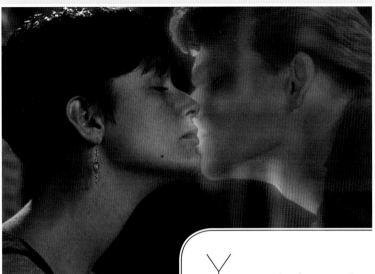

The clay kiss and the spiritual kiss

Ghost (1990)

You must be from another planet if you don't know the *Unchained Melody* kiss between Patrick Swayze and Demi Moore in *Ghost*, lasting the duration of the song. Never before has clay been able to turn on an entire audience as much as in this *snogtastic* scene. Fans of tragic love stories are in for a real treat at the end of the film during the heart-breaking Kleenex-sob-scene when Sam's ghost kisses his darling Molly for the very last time his soul is absorbed by a blinding white light.

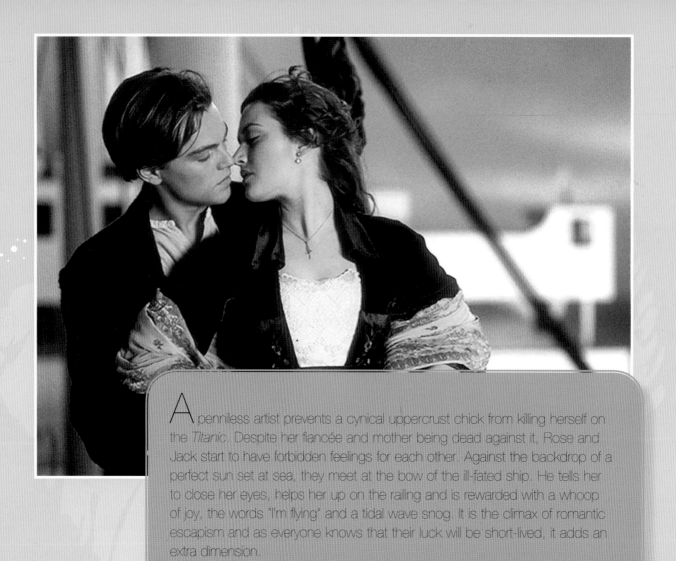

A penniless artist prevents a cynical uppercrust chick from killing herself on the *Titanic*. Despite her fiancée and mother being dead against it, Rose and Jack start to have forbidden feelings for each other. Against the backdrop of a perfect sun set at sea, they meet at the bow of the ill-fated ship. He tells her to close her eyes, helps her up on the railing and is rewarded with a whoop of joy, the words "I'm flying" and a tidal wave snog. It is the climax of romantic escapism and as everyone knows that their luck will be short-lived, it adds an extra dimension.

The bow kiss *Titanic* (1997)

"When a clumsy cloud from here meets a fluffy little cloud from there, he billows towards her. She scurries away, and he scuds right up to her, and there you have your shower. He comforts her. They spark. That's the lightning. They kiss. Thunder!"

Fred Astaire in *Top Hat* (1935)

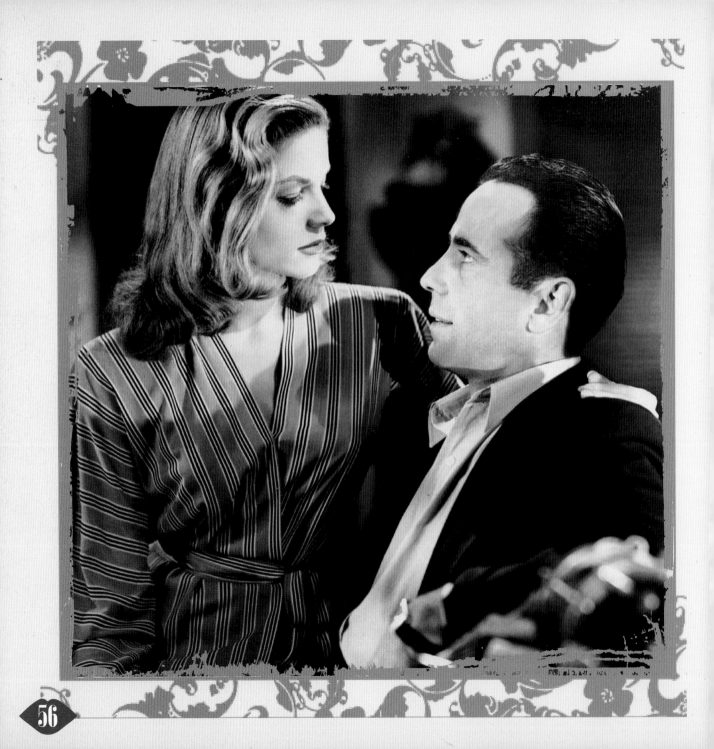

The sparks that came off the screen when Lauren Bacall and Humphrey Bogart starred together in *To Have and Have Not* have, even after 66 years, been unparalleled. It hardly came as a surprise when the 45 year old leading man immediately dumped his wife and started a passionate love affair with the 19 year old that lasted until he died. Aside from some unforgettable dialogue, this film is blessed with a top class kissing scene that is induced when the cold Slim unexpectedly sits on Steve's lap to kiss him.

To Have and Have not *(1944)*

Steve: "What did you do that for?"
Slim: "I've been wondering whether I'd like it."
Steve: "What's the decision?"
Slim: "I don't know yet."
(She kisses him again and this time he kisses her back)
Slim: "It's even better when you help."

A kiss to try

The shy kiss

Le fabuleux destin d'Amélie Poulain (2001)

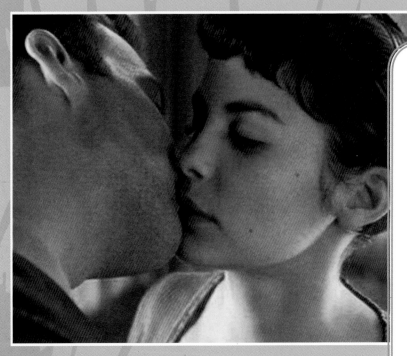

Charming but blushing violet, Amélie Poulain, dedicates her life to making other people happy. When she falls in love, she's unsure what to do with her own happiness. She plays a game that becomes increasingly more serious and ends when the man of her dreams visits her at home. Initially, she lets him leave again but soon enough, she runs after him and finds him standing in the hallway. She pulls his jacket and submerses him into her world, exchanging with him sweet little kisses on the cheeks and eyes. Like an irresistible dance unknown to anyone else.

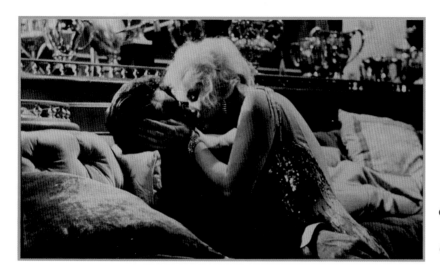

The professional kiss

In the classic comedy *Some Like It Hot*, Tony Curtis and Jack Lemmon, two musicians who are on the run from the Mafia, dress up as women and hide in a female orchestra. They both have the hots for singer Marilyn Monroe but it is Curtis who eventually pulls 'Sugar' by pretending he is a millionaire who has had no feelings since the death of his first girlfriend. Naturally, sex bomb Monroe takes on the challenge and after some tonsil lasting exercises, he admits that she has put all doctors, psychiatrists and experts in the shade.

Joe: "Where did you learn to kiss like that?"
Sugar: "I used to sell kisses for the milk fund."
Joe: "Tomorrow, remind me to send a check for $100,000 to the milk fund."

The Pop Art kiss
The Kiss (1964)

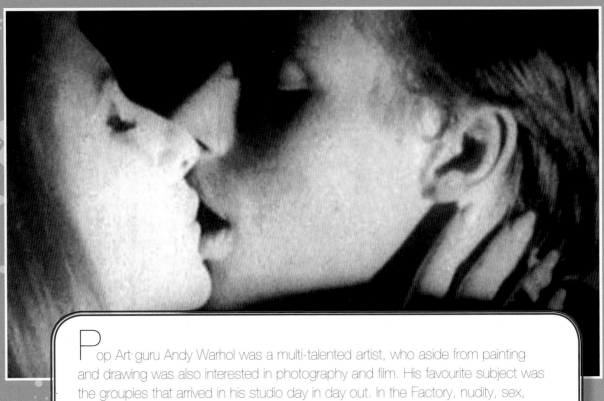

Pop Art guru Andy Warhol was a multi-talented artist, who aside from painting and drawing was also interested in photography and film. His favourite subject was the groupies that arrived in his studio day in day out. In the Factory, nudity, sex, drug use, homosexuality and transsexualism were everyday activities and therefore appeared in nearly all his work from that period. *The Kiss,* one of his first films, was a 50 minute 'snogathon', showing different pairs close-up licking each other's faces. Many of his films were considered socially unacceptable and cinemas that dared to show them were often closed due to obscenity.

"People who throw kisses are mighty hopelessly lazy."

Bob Hope (1903-2003), American comedian

61

The inevitable kiss

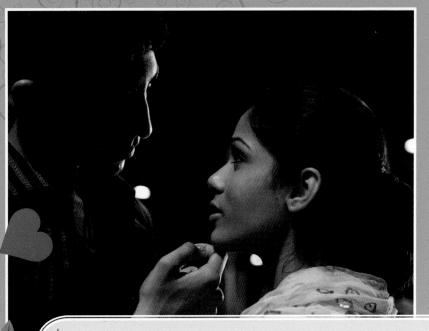

Slumdog Millionaire (2008)

In *Slumdog Millionaire*, Jamal finds himself in the *Who wants to be a millionaire* seat. Although everyone assumes that the street urchin will fail at the first hurdle, he gets through to the finals. It soon emerges that his intention was never to win the money but the love of the girl he has adored since they were little. The film is made for a Western audience but stays true to ancient Hindi traditions, prohibiting any kissing or scenes of a sexual nature. Instead, love must be shown through singing and dancing. In the final scene, Jamal whispers "This is our destiny" and softly kisses Latika on the cheeks. When he then brushes his lips against hers, the screen freezes and the end credits arrive accompanied by a dancing scene.

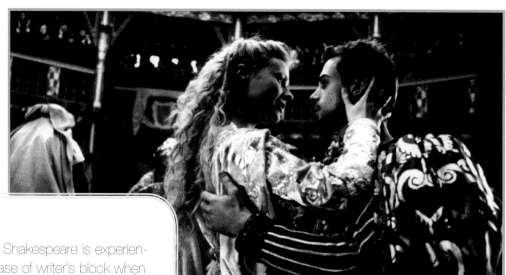

Young William Shakespeare is experiencing a serious case of writer's block when he meets Viola de Lesseps and sonnets start pouring out of his pen. Viola, who is forced to marry Lord Wessex, loves literature and dresses up as a boy in the hope that she can play a part in Shakespeare's latest play. When, in true Shakespearian style, Will finds out her double identity, they become entangled in a forbidden romance. Thanks to their true to life acting, *Romeo & Juliet* becomes a roaring success but sadly Viola will still have to join her fiancé and travel to a new continent. Torn by grief, they are allowed one final, dramatic kiss. From then on, Viola will forever be beyond reach for Shakespeare.

Shakespeare in Love (1998)
The final kiss

Will: "You will never age for me. Nor fade. Nor die."
Viola: "Nor you for me."
Will: "Goodbye my love, a thousand times goodbye."
Viola: "Write me well."

The forced kiss
On the Waterfront
(1954)

Edie: "Stay away from me"
Terry: "Edie you love me...
I want you to say it to me."
Edie: "I didn't say I didn't love you.
I said, 'STAY AWAY FROM ME."

The emotional climax in the trade union drama *On the Waterfront* takes place when dockworker Terry Malloy knocks on Edie's door, who has been avoiding him ever since he told her that he was there when her brother was murdered. He is not stopped by her angry "Stay away from me" and kicks the door in whilst she flinches in bed, holding onto a blanket, wearing a simple white nightdress. To his plea "Edie you love me... I want you to say it to me," she replies "I didn't say I didn't love you. I said 'STAY AWAY FROM ME'." They start to fight, he pushes her up against a wall, she makes a half-hearted attempt to push him off her. And then he kisses her. The music stops. They both slide down the same wall. Anger turns into passion. The sudden silence makes this even more powerful. A good kiss can stop the world from going around.

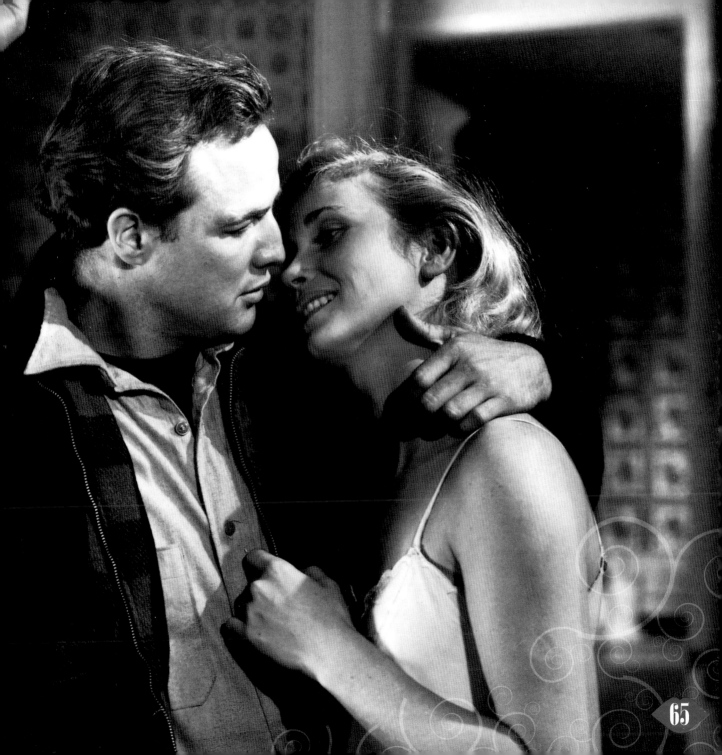

The library kiss
Atonement (2007)

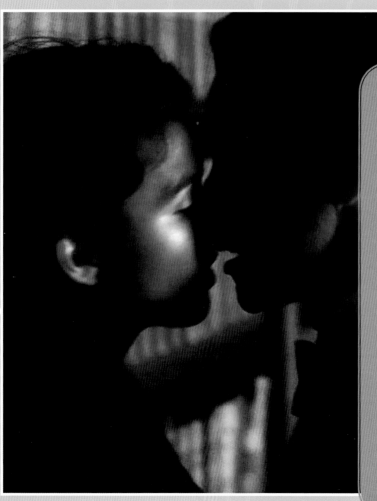

In *Atonement*, a blue-blooded girl starts a doomed romance with the son of the housekeeper. It is the summer of 1935 and they are obviously very uncomfortable with each other. "Why are you crying?", asks Robbie when he meets her in the private library. "Don't you know that?", asks Cecilia and of course, he knows. He runs towards her and kisses her like he has never done anything else. But then, their lips part and they stare each other in the eye for a long time. The tension mounts until passion takes over. A liptastic feast bursts out and, thanks to the inventive use of a bookcase, results in an intimate sex scene. "I love you," whispers Cecilia. "I love you'," says Robbie equally breathless. "I love this," thinks the audience.

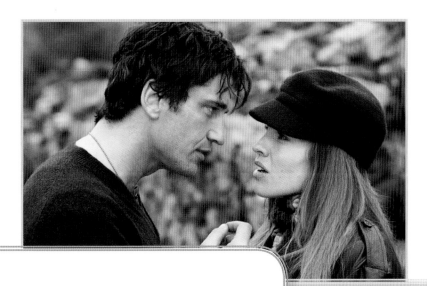

The fun factor of this film far outweighs the corny plot which shows that a romantic and funny kiss is worth another one. And another one... Widow Holly is a wreck after the premature death of her husband Gerry. The letters he left are taking her for a trip down memory lane. Back when they first met in Ireland, she was lost and he had tried to lure her into his arms by telling an absurd story about a wild dog. Holly had decided to play along, then turned around to kiss him, nearly breaking his nose in the process.

Gerry: "Ow." *(rubs his nose)*

Holly: "Oh, sorry. I haven't done this in a while. I've been seeing this boy, but we don't do much. I don't know why. Maybe it's me."

Gerry: "No, he's a boy who... doesn't know anything about kissing. That's a man's business."

Holly: "Is it?"

(He carefully lifts her chin and presses his lips onto hers)

Holly: "That was the most perfect... perfect first kiss."

Gerry: "That was the second. This is the third."

(He now holds her face with both hands and gives her the perfect film kiss)

The funny kiss

P.S. I love you (2007)

The final kiss that wasn't one
Casablanca *(1942)*

"Kiss me as if it were the last time," says Ingrid Bergman to Humphrey Bogart, knowing that she is unable to join him the next day when he flees occupied Paris. However, their love was meant to be, as a few years later, they come face to face again, this time in Casablanca. "If you knew how much I loved you. How much I still love you," whispers the married Ilsa, prepared to leave anything and everyone behind for the love of her life. The heartbreaking kiss that follows is, as it turns out, truly the last one.

Ilsa: "Kiss me as if it were the last time."

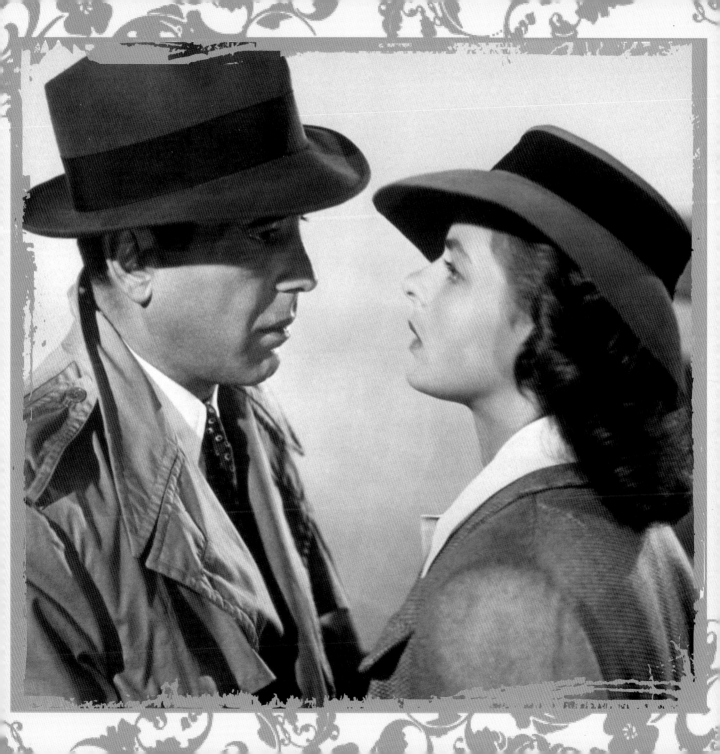

The Hollywood-kiss

From 1934, American films were governed by the Hays Code. Film characters were no longer allowed to kiss lying down. Married couples had to sleep in separate beds and if there was any horizontal smooching, at least one of the two had to keep a foot on the ground. Strictly forbidden were: sensual kisses and embraces, suggestive movements and poses, vulgarity, seduction and rape scenes, references to sexual perversity and interracial relationships. For more than 30 years, American films were made with these guidelines in mind. They were set up by the film industry itself in order to avoid government censorship. It wasn't until 1966 when extensive adjustments were made and 1968 when the code was replaced in favour of a rating system.

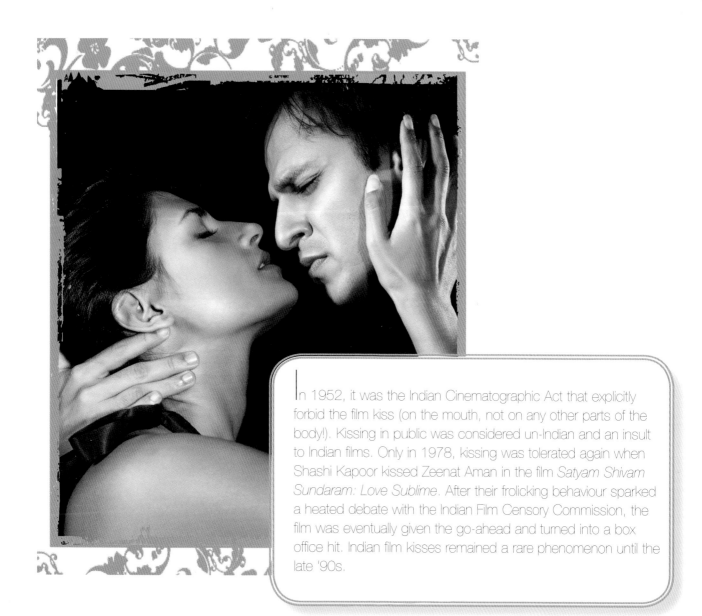

In 1952, it was the Indian Cinematographic Act that explicitly forbid the film kiss (on the mouth, not on any other parts of the body!). Kissing in public was considered un-Indian and an insult to Indian films. Only in 1978, kissing was tolerated again when Shashi Kapoor kissed Zeenat Aman in the film *Satyam Shivam Sundaram: Love Sublime*. After their frolicking behaviour sparked a heated debate with the Indian Film Censory Commission, the film was eventually given the go-ahead and turned into a box office hit. Indian film kisses remained a rare phenomenon until the late '90s.

The Bollywood-kiss

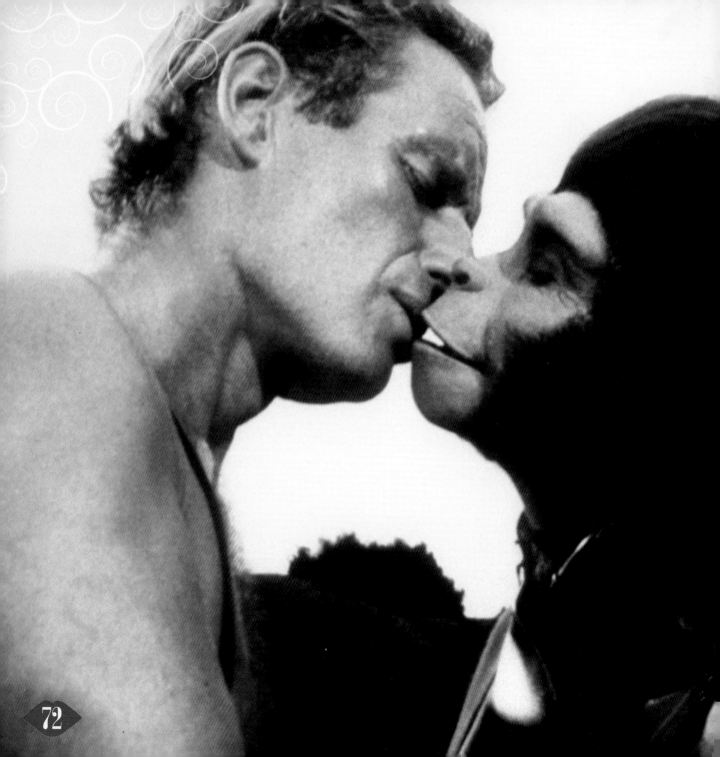

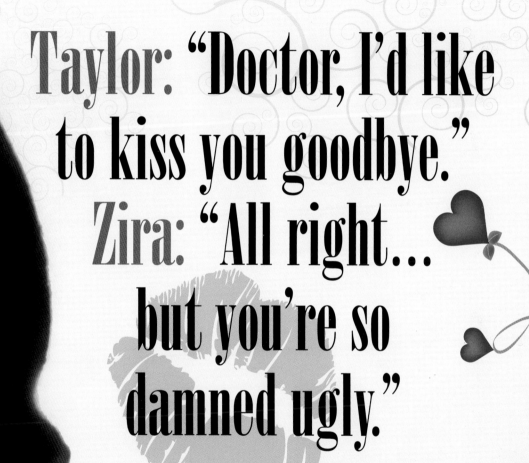

Taylor: "Doctor, I'd like to kiss you goodbye." Zira: "All right... but you're so damned ugly."

Charlton Heston & Kim Hunter in *Planet of the Apes* (1968)

73

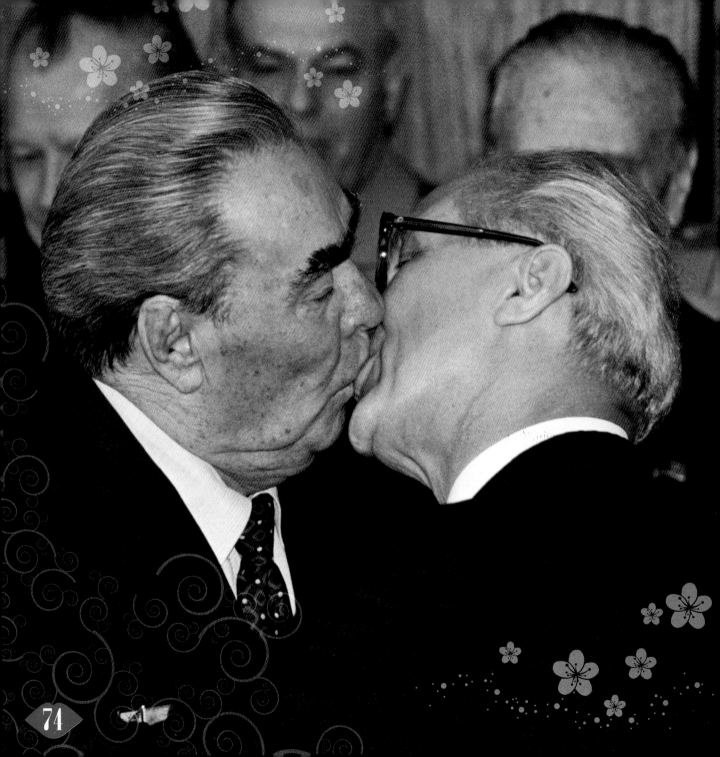

The real life

kiss

World record
kissing

In September 2010, American students Matt Daley and Bobby Canciello managed to successfully exchange saliva for an impressive 33 hours (!), and all this to raise awareness for LGBT rights (Lesbian, Gay, Bisexual, Transgender). Brave, as the rules are anything but a doddle: the lips of the contestants must be touching at all times, they must be awake and standing, they cannot lean or be propped up and no rest breaks or … nappies are allowed. Under these conditions, I can imagine that most people would rather stick to amateur canoodling.

If you would like to join in breaking the world record for snogging, have a look on the Facebook website of French Kiss World Record. Every few months, the French Institut Bonheur organises a new record attempt in different cities around the world, trying to find as many people who will form a chain and French kiss their left and right neighbour. Don't forget to brush your teeth!

French Kiss
World Record

The largest group kiss
New Mexico

On Valentine's day 2009, 39,987 people came together in New Mexico to break the world record for the largest group kiss. Whilst singer/actrice Susana Zalaveta sang *Besame Mucho*, all lips were simultaneously locked into a kiss for ten seconds. The event was organised by the local tourist office in an attempt to spread love in a time when Mexico seems to be inundated by drugs trafficking. Wonderful initiative, but what's with the uneven number of participants?

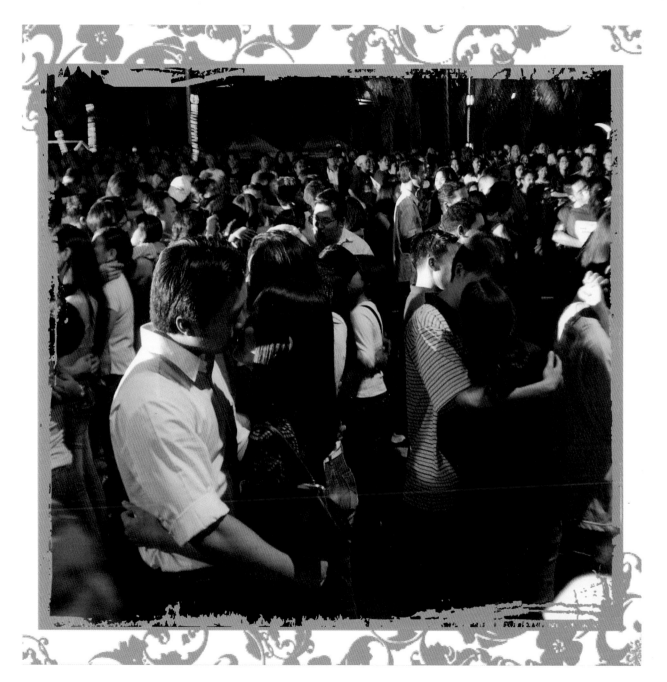

The kiss of life

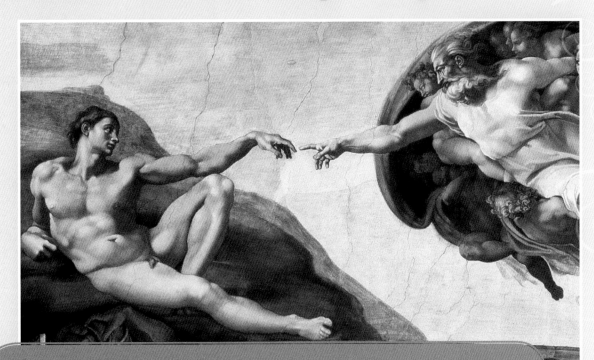

God and Adam seem to claim the very first kiss in history. If we are to believe the Bible, all life on earth was the result of this godly 'kiss of life'.

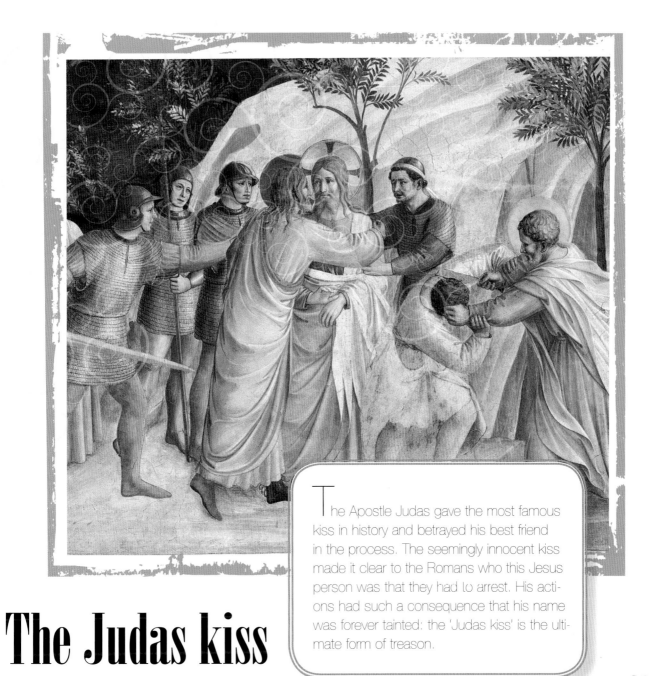

The Judas kiss

The Apostle Judas gave the most famous kiss in history and betrayed his best friend in the process. The seemingly innocent kiss made it clear to the Romans who this Jesus person was that they had to arrest. His actions had such a consequence that his name was forever tainted: the 'Judas kiss' is the ultimate form of treason.

"There you see her
Sitting there across the way
She don't got a lot to say
But there's something about her
And you don't know why
But you're dying to try
You wanna kiss the girl"

KISS THE GIRL (1989)
From The Little Mermaid
Written by Alan Menken & Howard Ashman
Performed by Samuel E. Wright

83

VJ-Day
Kiss

On the day of the American victory on Japan - which marked the end of World War II - Alfred Eisenstaedt photographed one of the most iconic kisses in history: a kiss between a sailor and a nurse on Times Square. As in a film pose, the man swings the woman back and plants a big smacker on her lips. Although this looks like a passionate reunion, Eisenstaedt claims that he had spotted the sailor a mile off, drunkenly zigzagging on Broadway, kissing every woman on the way.

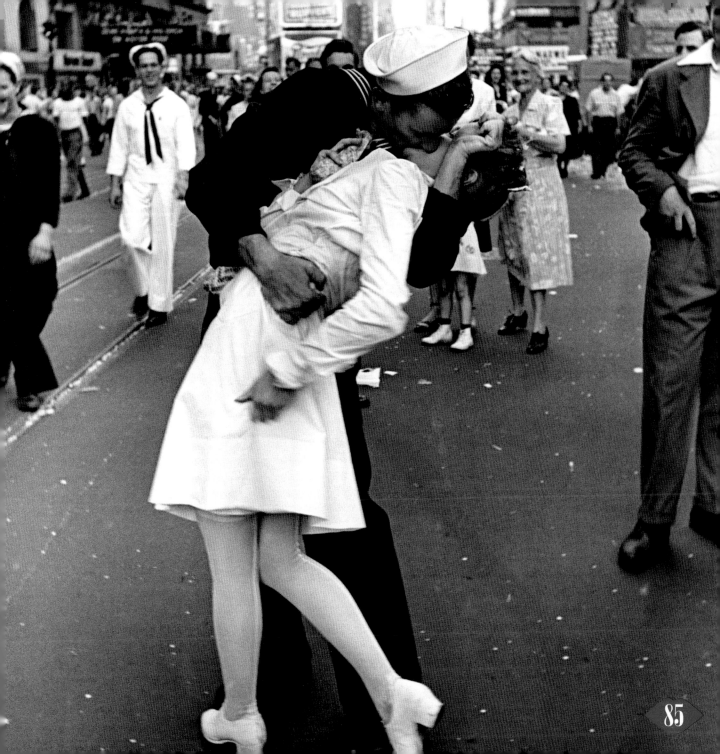

The Christmas kiss

Unwilling kissers are defenceless when standing under mistletoe. Since time immemorial, the tree parasite has been one of the most holy plants in European folklore. Its reputation as a catalytic kissing agent comes from a Scandinavian legend. Goddess Frigg made all living things swear an oath not to hurt her son Baldr, only she forgot mistletoe. Loki, the God of evil, made a projectile from this plant to kill Baldr. In a popular version of the folk tale, Frigg succeeded after three days to bring him back to life and her tears turned into the white berries on the mistletoe. Overjoyed, Frigg would have kissed everyone who walked under the tree which made the cursed plant grow.

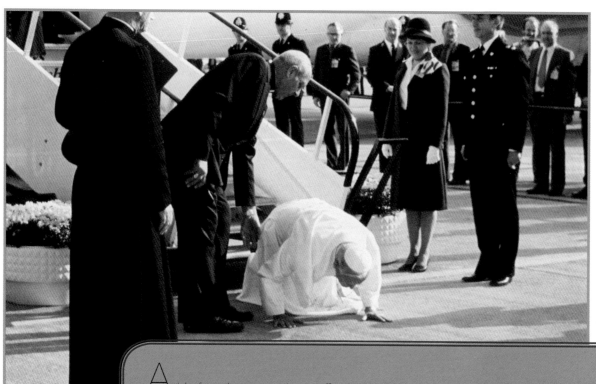

Aside from love, greetings, affection or betrayal, a kiss could also express humbleness, for example, when someone kisses the ring of a religious leader. Every time Pope John Paul II visited a foreign country, he would kiss the ground to show his respect for the country.

The humble kiss

"U don't have
2 be rich
2 be my girl
U don't have
2 be cool
2 rule my world
Aint no particular
sign I'm more
compatible with
I just want your
extra time and
your..... Kiss"

KISS (1986), Prince

89

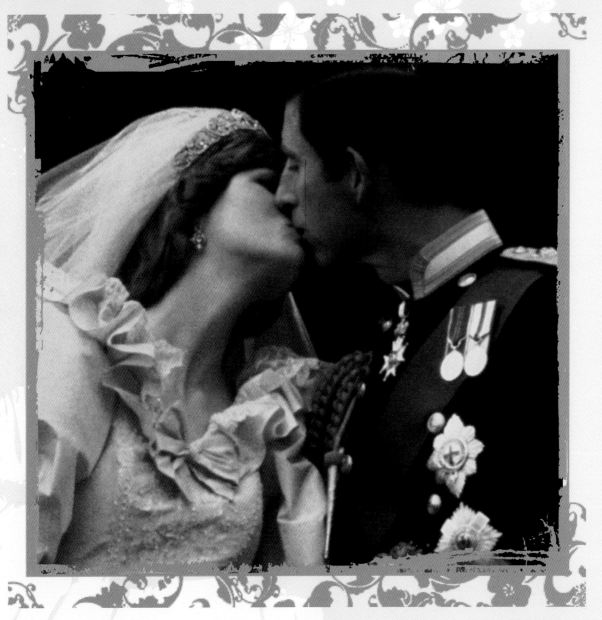

Charles & Diana
(1981)

The Royal kiss

On 29 July 1981, after having said yes to each other in front of 750 million people watching on TV, crown prince Charles and his bride Diana Spencer made their appearance on the balcony of Buckingham Palace. It had fully slipped Charles' mind to kiss Diana in church and the crowd roared: "Kiss, kiss, kiss!". For a split second, Charles seemed unnerved. He looked over to his mother, exchanged a few words with his bride and finally got in position for the long awaited kiss. Whilst Diana was making every effort to meet him in the middle, cool-as-a-cucumber Charles didn't do much else than present her with his Royal kissing instrument. The first wrong note in what should have been the biggest Cinderella story of the century.

Willem-Alexander & Máxima (2002)

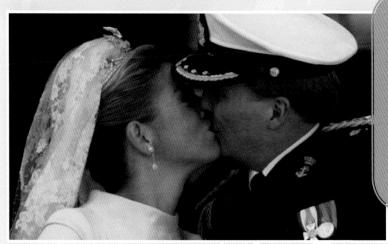

Dutch crown prince Willem-Alexander and his Argentinian bride Máxima Zorreguieta were quite the opposite. They were beaming on the balcony of the palace at the Dam and could hardly keep their hands of each other which led to five sincere kisses, making the orange crowd go crazy.

In 1837, Thomas Saverland tried to kiss the beautiful Caroline Newton at a party. She was not in the least bit impressed and bit off part of his nose. The injured playboy took the bull terrier lady to court but was outraged to hear that a woman is in her right to defend her virtuousness, even if this involves violence. To date, Saverland v. Newton is still regarded as the forerunner of court cases with regard to sexual intimidation. Now we know where the expression 'to bite someone's nose off' comes from!

The prevented kiss

The forbidden kiss

Warrington's Bank Quay station, UK (2009)

Sometimes the government acts slightly over the top when it comes to rules and regulations. For example, in 1979, a 'No-Kissing Zone' was created at the station of the American city of Deerfield to cut down on traffic jams. Those who couldn't resist kissing were directed to the 'kissing zone' at the car park - an invention that became so popular, they had to lock up the signs at the weekend to stop them from being stolen. Exactly thirty years later, *officials* at Warrington Bank Quay station in the UK tried to establish a similar ban but had to remove the board three weeks later due to heavy protest.

"A soft and hot kiss is the rubber which erases the rest of the world."

Romain Guilleaumes (Bernard Willems-Diriken, born 1963), Belgian moralist

95

The capital of the kiss

From now on, Mexican mayor Eduardo Romero will think twice about disallowing his citizens to kiss. Apparently, he considered the public display of affection in Guanajuato to be too open and introduced in January 2009, an anti-obscenity law that prohibited kissing in public. Perhaps slightly ironic as the biggest tourist attraction of the city is El Callejón del Beso, the 'kissing alley'. An overwhelming protest meant that, after a few days, the law had to be abolished and the city was proclaimed the 'capital of the kiss' by the mayor. *If you can't beat them, join 'em.*

Prince William is greeted with a hongi in New Zealand (2010)

Ancient Egyptians rubbed their noses together whilst sniffing each other's breath. Inuits, Hawaiians and New Zealanders still greet each other this way and call it kunik, honi and hongi. Kissing is an unknown phenomenon with Somali people, the Lepcha of Sikkim and Sirono in Bolivia. In China, Japan and strict Muslim countries such as India and Vietnam, kissing in public is a rare occurrence. In Oman, it's not unusual to see men kissing each other's nose. Many European and Latin American people greet each other with a kiss on the cheek, although there are regional differences. Russians, Slovenians, the Dutch and Egyptians usually peck three times, Belgians give one or three kisses depending on who they are greeting and the British like to keep it even and go for two. France is a case on its own: in Paris, they kiss four times, in Brittany three, the Côte d'Azur sets you back with an abundance of five to six pecks and the rest of France keeps it at two. The Americans are most economical and keep it at one simple peck on the cheek.

The kiss as a greeting

The animal kiss

Birds press their beaks together. Dogs and foxes lick each other's faces. Turtles, moles and cats rub their noses together. Slugs caress each other's tentacles. Elephants put their trunks in their friends' mouths. Chimpanzees and bonobos passionately French kiss their mates. Facial contact is not only custom amongst mammals but also bird species and reptiles. Not surprising that Darwin wondered if kissing was an inborn instinct.

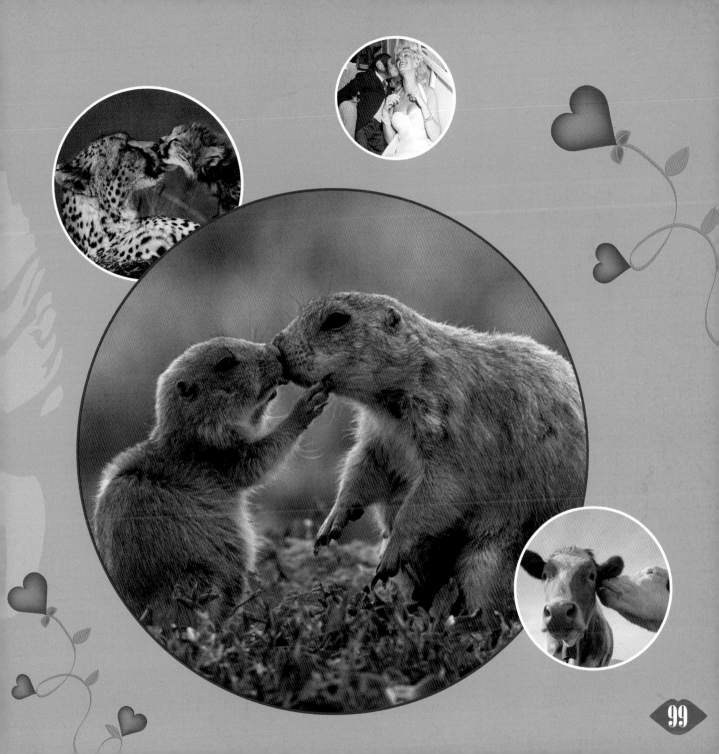

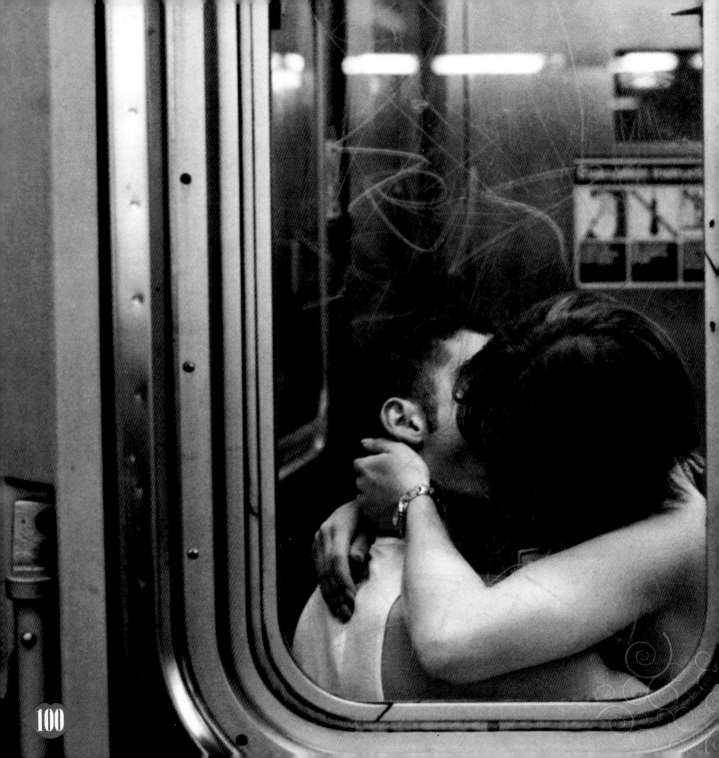

"Any man who can drive safely while kissing a pretty girl is simply not giving the kiss the attention it deserves."

Albert Einstein (1879-1955), German-Swiss-American physicist, philosopher and author

Kissing day

Mark 6 July in your diary. What started 20 years ago as National Kissing Day in the UK, was adopted by the United Nations as International Kissing Day. Particularly in Russia and the UK, many competitions, events and festivals are organised on this day, reminding people of the simple pleasures of kissing.

Père Lachaise
(Paris)

The *really lucky guys* even get kissed after their death. The tomb of poet Oscar Wilde at the Père Lachaise cemetery in Paris is covered in lipstick kisses from hundreds and thousands of visitors (mainly gay men) who show him their respects every year. The grave of the 19th century journalist Victor Noir at the same cemetery had to be protected from the public in 2004 as some ladies were slightly too attracted to his sculpture for the following three reasons: his reputation as a romanticist, the legend that says you will find a husband if you kiss his lips and place a flower in the top hat and the rather inviting nobble in his trousers.

The everlasting kiss

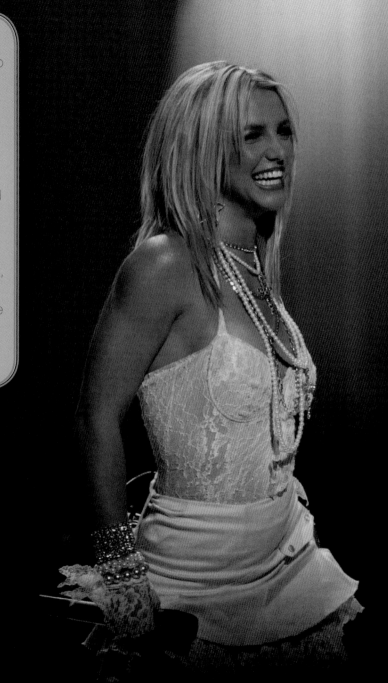

It was the 20th edition of the MTV Video Music Awards. Britney Spears and Christina Aguilera opened the show with Madonna's '80s hit Like A Virgin, dressed provocatively in wedding dresses that became increasingly shorter. Whilst the music faded from the bridal march into Hollywood, Madge herself appeared from the cake dressed as a groom. The audience went bonkers when she snogged little BritBrit and the streetwise Christina with much appetite. Missy Elliot, who appeared on stage straight after, had clearly missed the boat. The 'double lesbian kiss' got tongues wagging and became an enormous success on the internet.

The MTV- kiss

Madonna, Britney Spears & Christina Aguilera (2003)

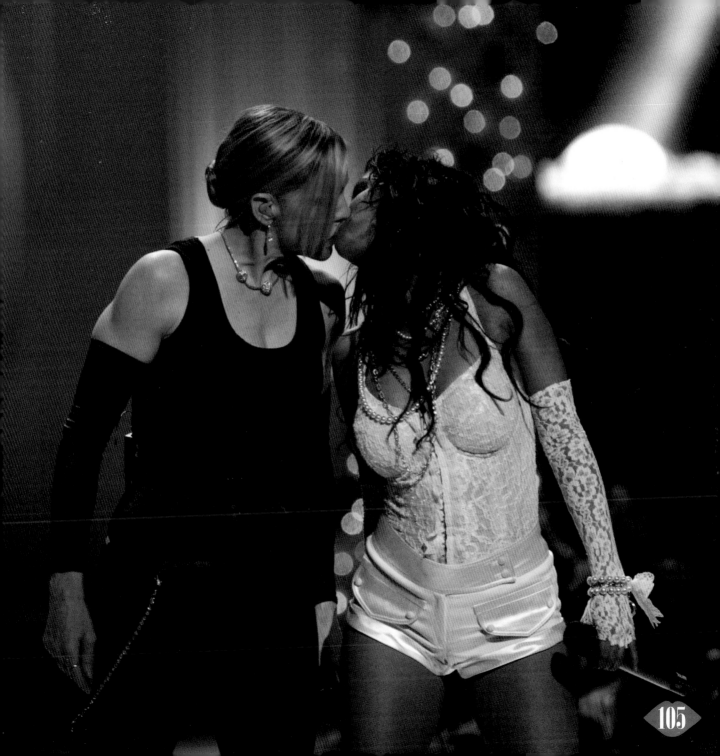

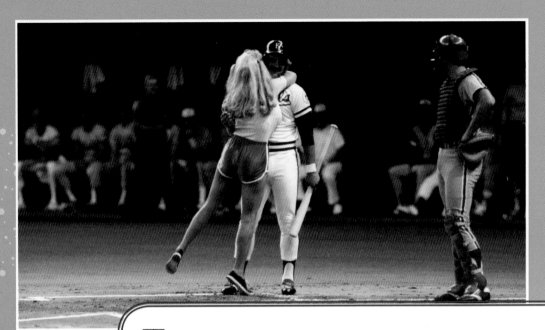

The straightforward stripper Morganna Roberts made a career kissing famous sports players. She was crowned 'the Kissing Bandit' in 1971 when at the age of 17, her friend had challenged her to kiss Reds player Pete Rose. By 1990, she had kissed 37 Major League baseball players, 12 NBA players, dozens of minor league players and various umpires, managers and owners. Her pastime was not without its hazards as she suffered various injuries jumping from stands onto playing fields and was arrested nearly 20 times. But her appearances did make her famous and brought in the money.

Famous kissers
The kissing bandit

"I have found men who didn't know how to kiss. I've always found time to teach them."

Mae West (1893-1980), American actress

Famous kissers
Sandra Bullock *(2010)*

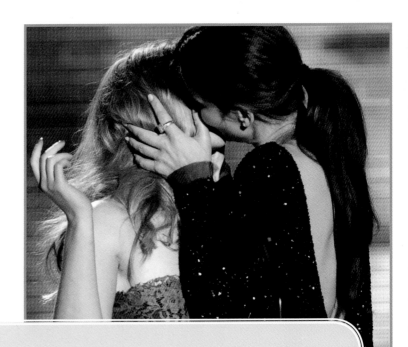

Sandra Bullock only needed a few months to establish her reputation as a famous kisser. In January 2010, she kissed Meryl Streep during the Critics' Choice Movie Awards and in June of the same year, she shared the infamous kiss with Scarlett Johannson at the MTV Movie Awards. Both kisses were pretty hilarious thanks to the comical talent of the 46 year old actrice, who, for once and for all, wanted to make it clear that she wasn't going to be ground down by the press for splashing her divorce all over the media. "Now that we have done that, can we please go back to normal?" she asked the audience, who promptly gave her a standing ovation.

When Robbie Williams sings *Kiss Me*, he means business. As in Knebworth, in 2003 and in Sydney a year later, the performer is known to pick out a girl during his concerts, to invite her on stage and finish it off - whilst singing - with a game of tongue wrestling (yes, it's a rare skill). The ex-Take Thatter is also known for his affairs with groupies but that's an entirely different story.

Famous kissers

Robbie Williams

In 2007, Richard Gere caused a row during an Indian Aids benefit when he tried to charm Shilpa Shetty. The Bollywood actrice was dumbstruck when the American actor kissed her hand during a press conference. Unaware of the angry reaction from the audience and the desperate struggle to free herself from his arms, the 58 year old Adonis couldn't think of anything better than to bow her over for a proper Hollywood-kiss. The incident caused extremists to burn Richard Gere voodoo dolls and an Indian court even issued a warrant for their arrest.

The unwanted kiss

Richard Gere & Shilpa Shetty
(2007)

"A legal kiss is never as good as a stolen one."

Guy de Maupassant (1850-1893), French writer

The victory kiss

Adrien Brody
& Halle Berry
(2003)

The Jewish actor Adrien Brody stole the show during the Oscars in 2003. When his name was called out by Halle Berry as the winner of the Academy Award for the Best Actor for his role in *The Pianist*, he surprised everyone (not in the least Berry) by storming on stage and passionately kissing her. With the award in hand and his speech to come, he couldn't hold back a tiny joke first: "Bet you didn't know that was in the gift bag." When he then became all emotional thanking his mother, who was his date for the evening, all the women in Hollywood were head over heels.

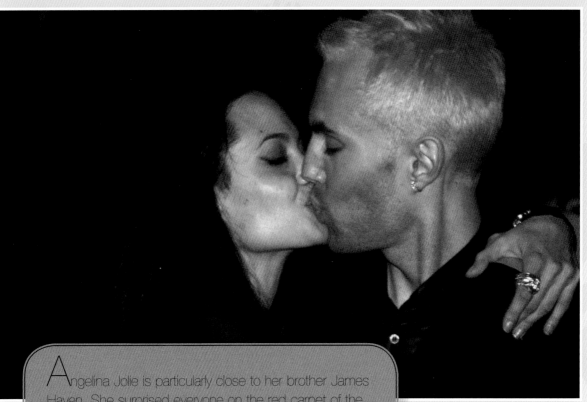

Angelina Jolie is particularly close to her brother James Haven. She surprised everyone on the red carpet of the Academy Awards in 2000 when she kissed her two year older brother rather ardently on the mouth. The press went mad and pictures of this 'scandal' appeared in every corner of the world. "I did not snog Angie, it was merely something simple and beautiful," protested James. "I congratulated her on her Oscar and quickly kissed her on the lips. Pictures were taken and the whole thing was blown out of proportion."

Angelina Jolie & James Haven (2000)

The incestuous kiss

The awkward kiss

The world went mad when in 1994, news broke that the King of Pop had secretly married the daughter of the King of Rock-'n'-roll. Michael Jackson and Lisa Marie Presley first appeared as a couple at the MTV Video Movie Awards of that year. With a nod to his clearly embarrassed wife, Jackson said: "And just think, nobody thought this would last." The awkward kiss that followed was immediately splashed out on every gossip magazine's front page. Their relationship had been used as a diversion for his upcoming court cases. Presley said later: "I was terrified. It was his manager's idea." Barely two years later, the divorce was settled.

Michael Jackson
& Lisa Marie Presley
(1994)

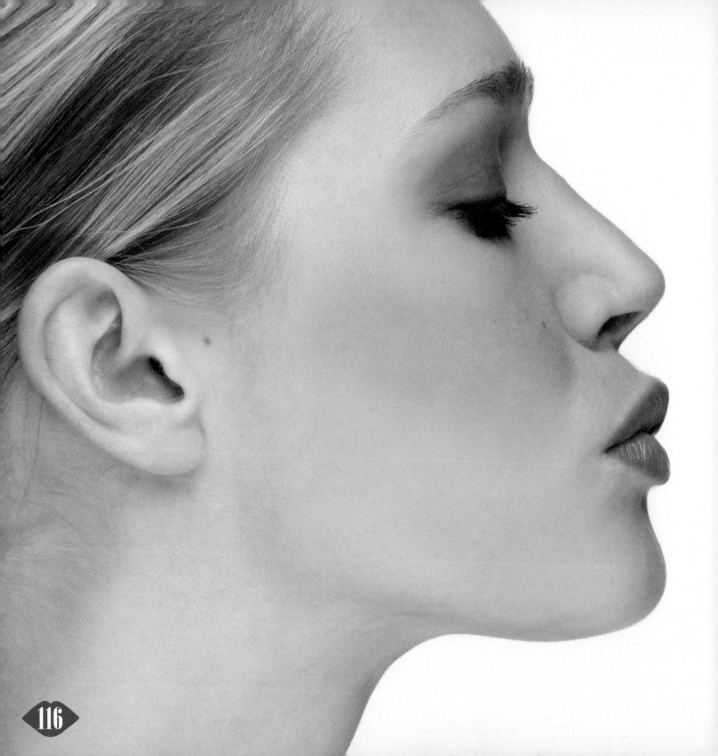

Soul meets soul
on lovers' lips.

Percy Bysshe Shelley (1792-1822), English poet

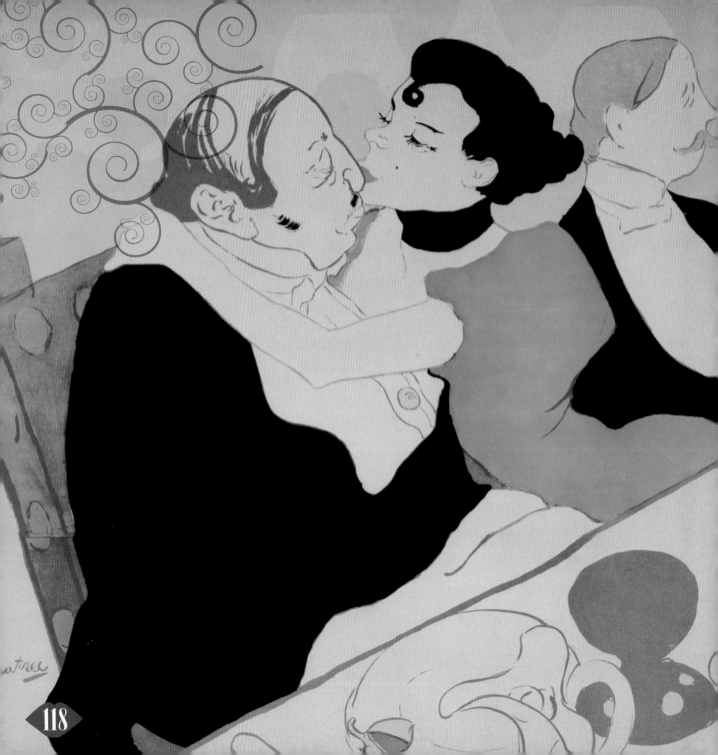

The Artistic

kiss

The first kiss in art

Erastes and Eromenos
(480 B.C.)

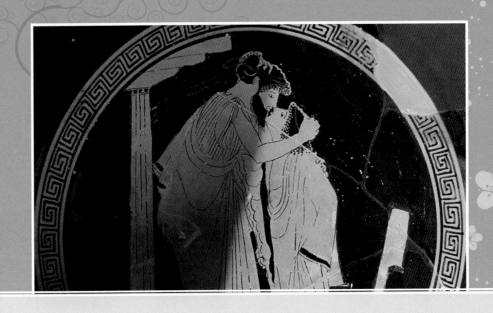

Images of a kiss first appeared in Etruscan times; however, not many examples are left. Therefore, the first true image is that of a homosexual kiss on the inside of a red-figured Attic kylix (wine cup) dating back to 480 BC. It depicts the intimate moment between Erastes and Eromenos (older lover and younger beloved) painted by the Briseis Painter (as Attic artwork has no signature, the artist is often named after the place where the object was found).

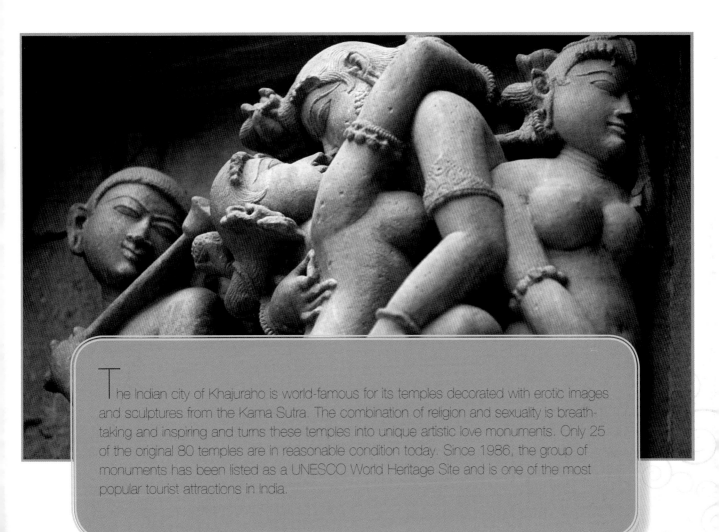

The Indian city of Khajuraho is world-famous for its temples decorated with erotic images and sculptures from the Kama Sutra. The combination of religion and sexuality is breathtaking and inspiring and turns these temples into unique artistic love monuments. Only 25 of the original 80 temples are in reasonable condition today. Since 1986, the group of monuments has been listed as a UNESCO World Heritage Site and is one of the most popular tourist attractions in India.

The Indian kiss
Khajuraho
(950-1050 A.D.)

Der *Kuss*

(1907-1908)

Largely painted with gold leaf, *Der Kuss* is the most famous work of Gustav Klimt, the Austrian painter and graphic artist who stood at the cradle of the Viennese Jugendstil. Some think that Klimt and his close friend Emilie Flöge modelled for the masterpiece but that he changed the faces at the last minute. The painting became world-famous during the Flower Power period and has since been printed on numerous posters and cards.

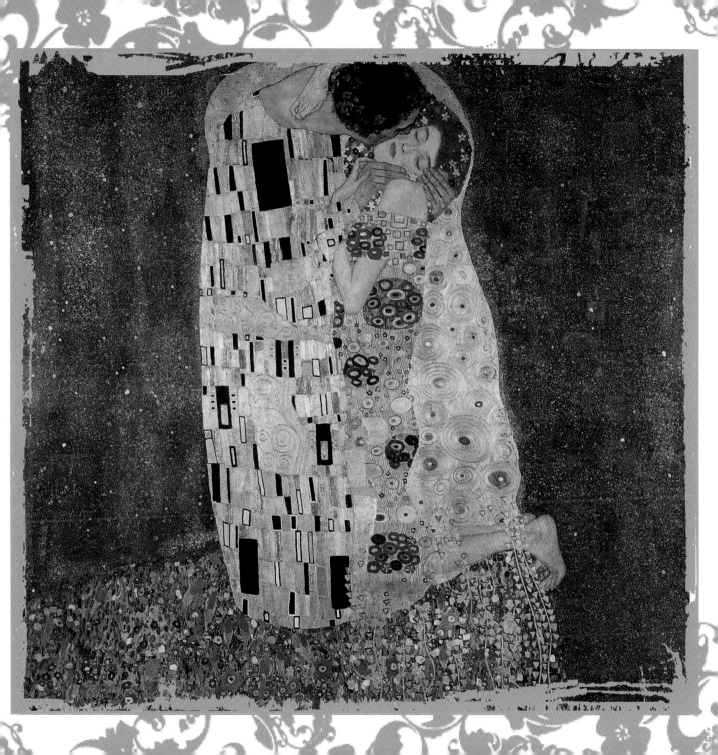

The cubist kiss

El beso (1969)

The Spanish cubist Pablo Picasso dedicated a whole series to the kiss in an attempt to portray the perfect example. One of his attempts from 1969 fetched EUR 14.6 million in mid 2010 at a Christie's auction in London.

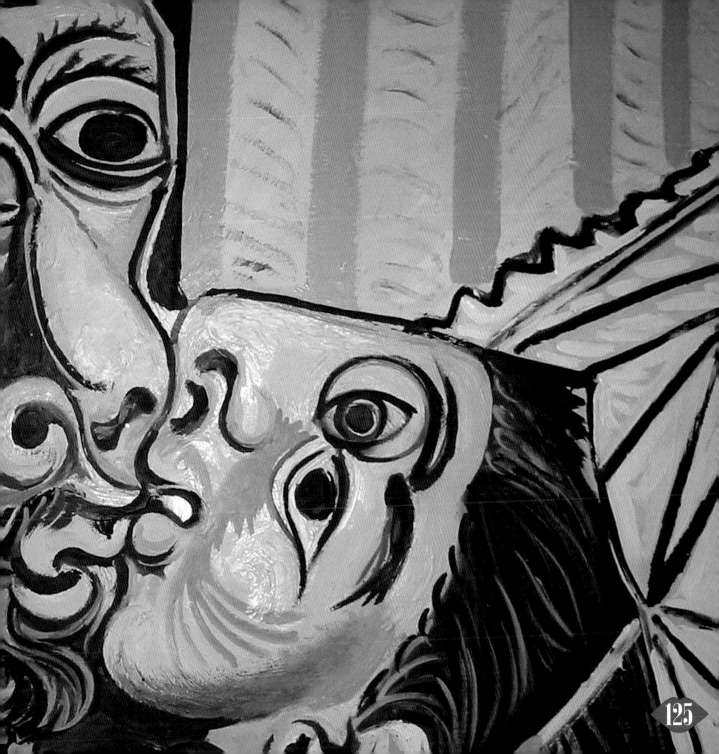

The melting kiss
Der Kuss
(1898)

The Norwegian artist Edvard Munch, known world-wide for his expressionist painting *The Scream*, also drew and painted a series of works inspired by the kiss. The way both faces fade into one symbolises the way people seem to lose their identity when they are in love. The characters radiate an intensity that is difficult to describe in words and make you wonder how much further they can go before they become one.

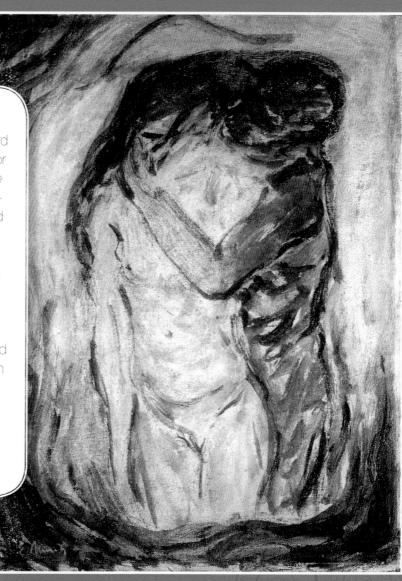

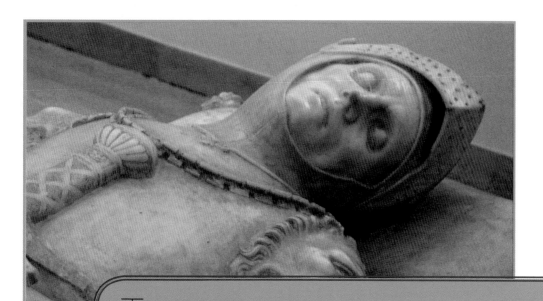

The 16th century Italian soldier Guidarello Guidarelli has seen more action after than before his death. The legend that whoever kisses the statue will be married within the year, has been luring desperate women to Ravenna since the 18th century. More than five million women have pressed their lips on the marble statue, not without huge implications. When in 2004, the lipstick covered statue of Tullio Lombardo had to be cleaned again, the decision was made to protect it once and for all from over-enthusiastic ladies by putting a glass cover on it.

Guidarello Guidarelli
(16th century)

The most kissed sculpture

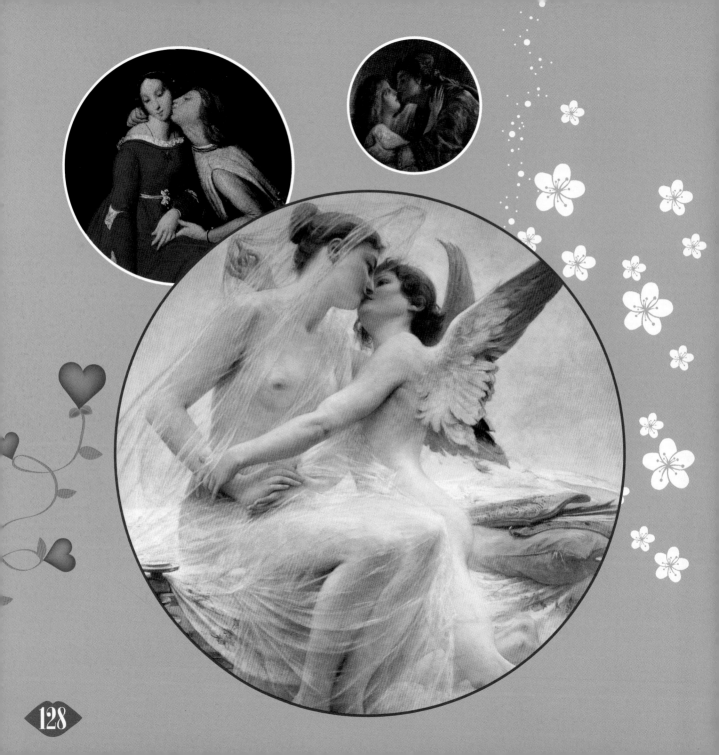

"Oh, kiss me, beneath
the milky twilight
Lead me out on the
moonlit floor
Lift your open hand
Strike up the band and
make the fireflies dance
Silver moon's sparkling
So kiss me"

KISS ME (1997) , Sixpence None the Richer

129

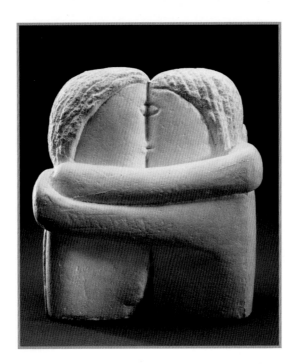

The abstract kiss
Le Baiser (1907)

In 1903, Romanian sculptor Constantine Brancusi left home by foot to devote himself to the arts in Paris. He became Auguste Rodin's assistant but left after two months to pursue his own vision. In the following years, he made many versions of *The Kiss*, further simplifying its form. He used this sculpture as a logo which signified unity, balance and love for life. A Romanian legend says that a kiss under the *Gate of the Kiss* in Targu Jiu guarantees a joyful marriage.

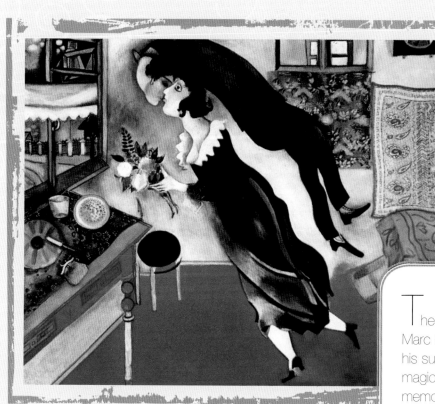

The birthday kiss

L'Anniversaire (1915)

The French-Russian painter Marc Chagall was famous for his surrealistic paintings which magically portray some of his memories. When in 1915, he had left Paris to visit his place of birth Vitebsk, Bella Rosenfeld had presented him with a bouquet of flowers for his birthday. Eighteen days later they were married. His work *L'Anniversaire* directly refers to the first visit of his later wife.

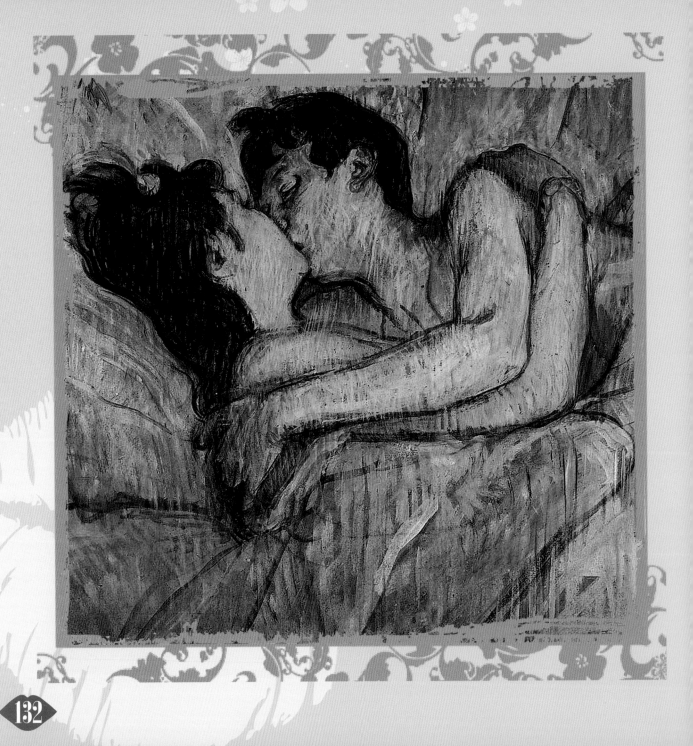

The lesbian kiss
Le Baiser *(1892)*

Henri Toulouse-Lautrec was fascinated by the lesbian love between the Paris prostitutes and dancers who he spent time with on a regular basis. From 1890, he devoted a series of sketches and paintings to the subject, of which Le Baiser (1892) was the most explicit example. Lautrec was a genius at conveying body language and this work was a fine example, with two women lying on a bed in a passionate embrace.

"A man had given all other bliss,
And all his worldly worth for this,
To waste his whole heart in one kiss
Upon her perfect lips."

From *Lancelot and Queen Guinevere* by Lord Tennyson (1809-1892)

The brotherly kiss

Mein Gott, hilf mir diese tödliche Liebe zu überleben (1989)

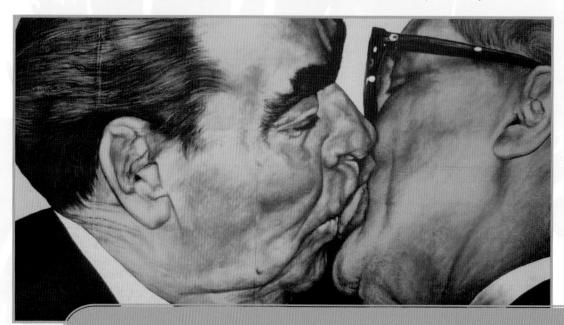

When in 1989 the Berlin Wall fell, Russian painter Dmitri Vrubel was one of the many artists who claimed some of the remains. His famous mural depicts Soviet leader Leonid Brezhnev and East German leader Erich Honecker kissing during the celebrations in 1979 of 30 years of the GDR. The brotherly kiss, which was greeted with jeers in the West, was in the East a normal expression of socialist solidarity (although the men do look like they are having rather a good time!). As the painting had become damaged due to weather conditions and over-enthusiastic tourists, it was decided in 2009, to have it repainted on part of the renovated wall.

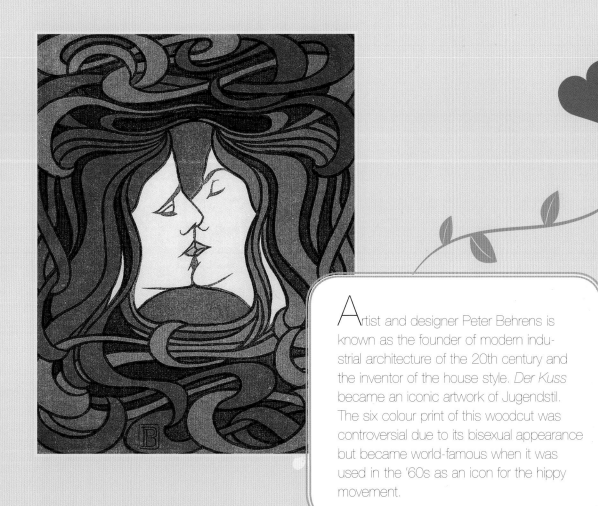

Artist and designer Peter Behrens is known as the founder of modern industrial architecture of the 20th century and the inventor of the house style. *Der Kuss* became an iconic artwork of Jugendstil. The six colour print of this woodcut was controversial due to its bisexual appearance but became world-famous when it was used in the '60s as an icon for the hippy movement.

The Art Nouveau kiss
Der Kuss (1898)

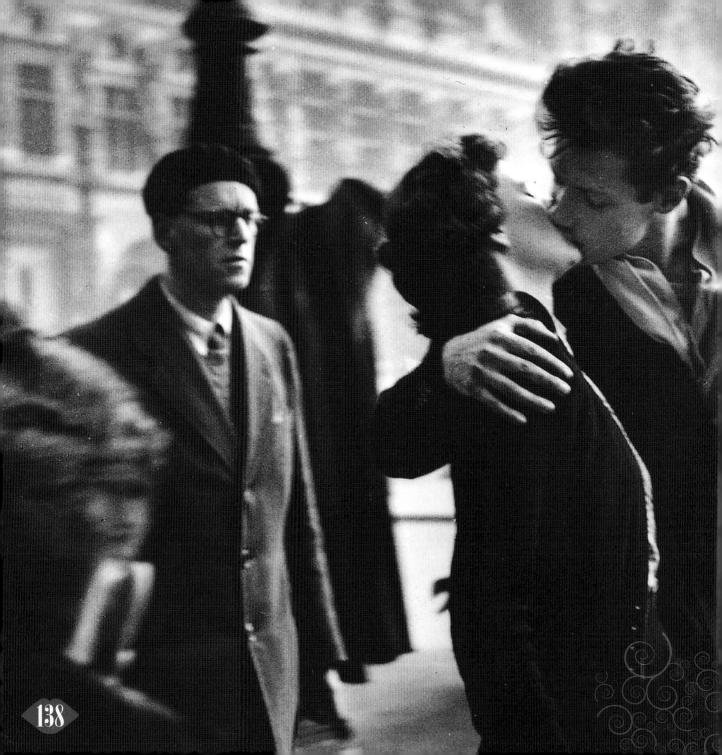

Le baiser de l'hôtel de ville
(1950)

The staged kiss

For the past 60 years, this photo adorned more girls' rooms than all pop and film stars together. The nostalgic images of the French working-class districts in Paris made Robert Doisneaus world-famous. *Le baiser de l'hôtel de ville*, which he photographed in 1950 for LIFE magazine, soon became a symbol of love. The identity of the kissers remained a mystery until in 1993, when the photographer was taken to court by a couple that claimed to be them in the photograph, and he had to admit that the scene was staged. After he had seen Françoise Delbart and Jacques Carteaud kiss on the street, he asked if they would mind kissing again in different locations in front of the camera. "I would never have dared to photograph people like that. Lovers kissing in the street, those couples are rarely legitimate."

The Queen's kiss

Hercule et Omphale (1735)

In order to pay for the murder of his friend Iphitus, Hercules is handed over to Omphale, the queen of Lydia for a year. She forces him to wear a dress and take care of womens' chores, but to ease his suffering, she allows him to be her lover - and a little later, even her husband. This story, which appears both in Greek and Roman mythology, inspired the French rococo painter François Boucher to create one of the most daring and erotic paintings of the century.

The forbidden kiss

L'Amour et Psyché, enfants
(1890)

This word-famous painting from the French painter William-Adolphe Bouguereau depicts the mythological characters of Cupid and Psyche as children. Psyche was so stunning, people started to honour her rather than Venus. This upset the Goddess of love, beauty and fertility so much that she sent her son Cupid to her to ensure she would fall in love with the most dumb and ugly man possible. However, Cupid, clumsy as he is, hurt himself with one of his arrows, making him fall madly in love with her. The story of these lovers who weren't meant to be together has been the subject of many artworks.

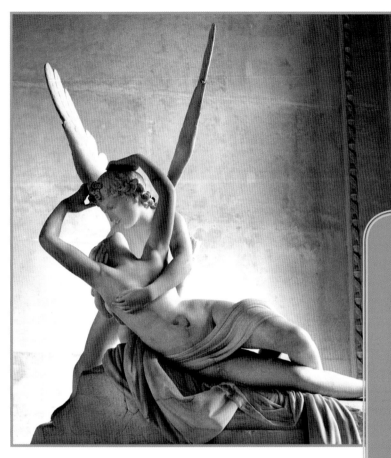

Amore e Psiche *(1788)*

Love was the favourite subject of the Venetian sculptor Antonio Canova, who was known for the way he gave naked skin a velvety look. As Bouguereau, he was inspired by the story of the forbidden love between Cupid and Psyche. Canova wasn't all that pleased with the sculpture as it had a black line running through the marble. Art experts still consider it to be a masterpiece in every sense.

The winged kiss

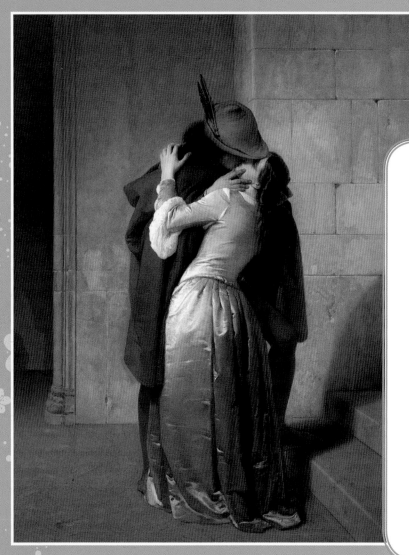

Portrait painter Francesco Hayez even managed to include a touch of Italian patriotism in this painting depicting a kissing couple. The kiss, of which there are four versions, shows a man and a woman during a romantic moment in a lost corner. Hayez included the colours of the Italian and French flag in their clothing, referring to the victory of both parties in the second War of Italian Independence. He consciously obscured their faces in order to focus on the action of the kiss and the shadows in the corner, indicating hidden danger.

The patriotic kiss

Il Bacio (1859)

"You have to kiss me. It's the law."

Susan Mayer (Teri Hatcher) in *Desperate Housewives*

145

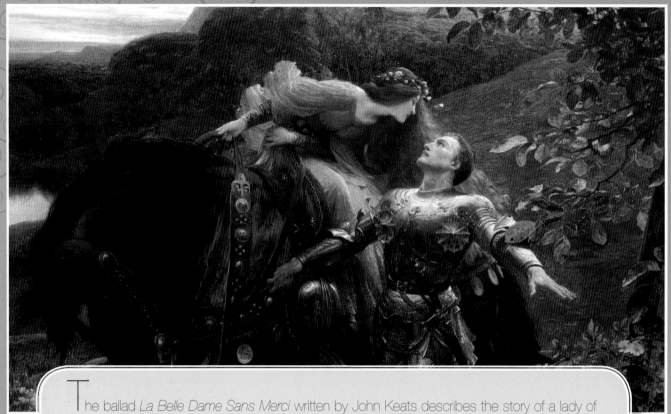

T he ballad *La Belle Dame Sans Merci* written by John Keats describes the story of a lady of unearthly beauty who bewitches an unnamed knight and leaves him to die a slow death, surrounded by a dead world. This is just up the street of the Pre-Raphaelites who loved painting mysterious and dead women, whether or not accompanied by lonely or introvert heroes. Sir Frank Dicksee's painting depicts the unfortunate knight looking longingly at his beauty, sitting on his horse, bending over for a kiss.

The deadly kiss

La Belle Dame Sans Merci (1890)

The life-granting kiss
Pygmalion et Galatée

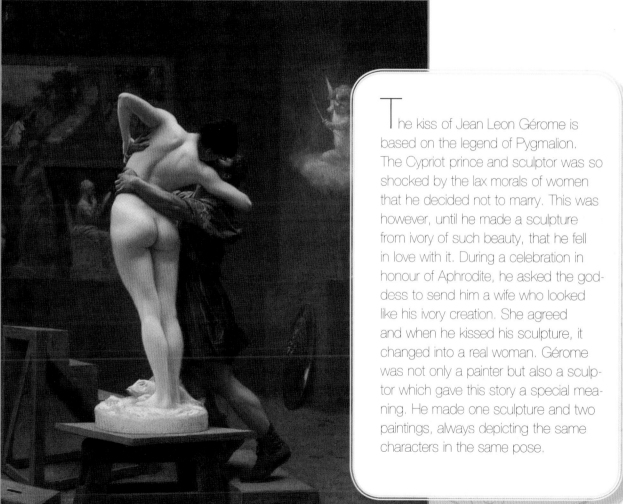

The kiss of Jean Leon Gérome is based on the legend of Pygmalion. The Cypriot prince and sculptor was so shocked by the lax morals of women that he decided not to marry. This was however, until he made a sculpture from ivory of such beauty, that he fell in love with it. During a celebration in honour of Aphrodite, he asked the goddess to send him a wife who looked like his ivory creation. She agreed and when he kissed his sculpture, it changed into a real woman. Gérome was not only a painter but also a sculptor which gave this story a special meaning. He made one sculpture and two paintings, always depicting the same characters in the same pose.

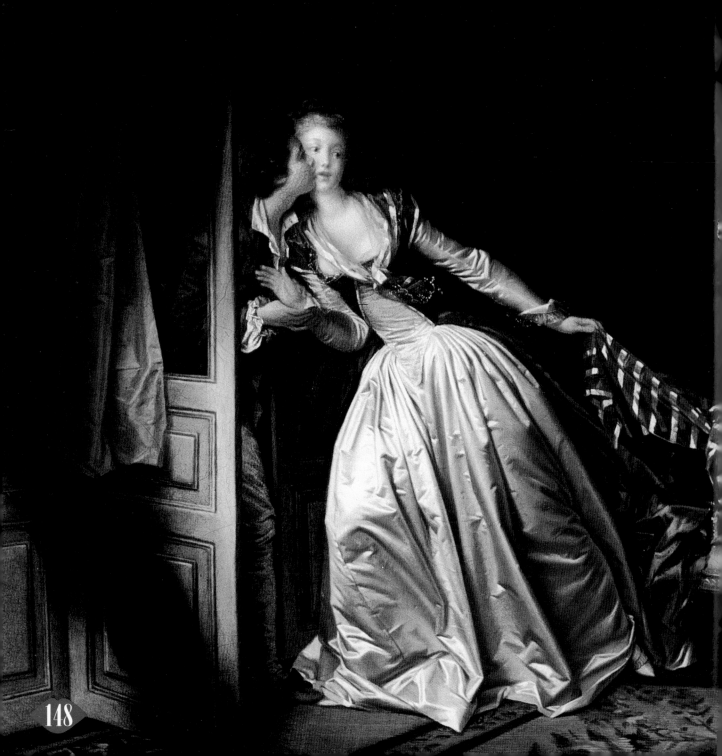

The stolen kiss
Le baiser volé
(1790)

The noble young lady in *Le baiser volé* only makes a half-hearted attempt to avoid the lips of the young man that has appeared out of nowhere. Jean Honoré Fragonard was a multi-talented French artist who mastered a large number of styles and techniques and who was famous for his extreme eye for detail. Love was one of his favourite subjects.

The sculptured kiss
Le Baiser (1886)

The most famous embrace in Western art was initially condemned for its blatant sensuality. *Le Baiser* was part of a much larger set-up: the characters of Paolo Malatesta and Francesca da Rimini appeared originally as part of a group of reliefs on a bronze door depicting Dante Alighieri's *Divina Commedia*. Paolo's deformed older brother, the man whom Francesca was made to marry, kills the couple after he discovers them. By only displaying this essence, Auguste Rodin transforms this boring literary story into a timeless sculpture of love.

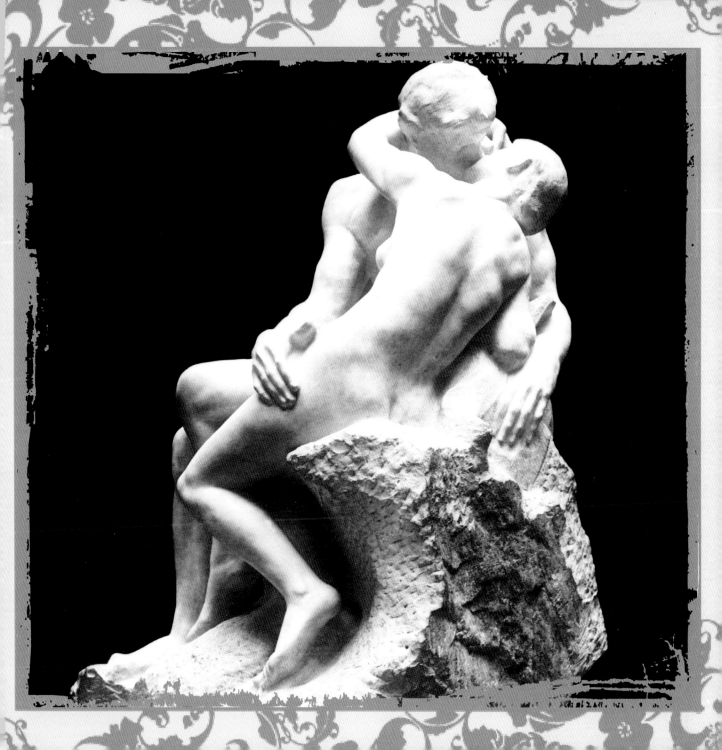

"You must
remember this
A kiss is just
a kiss
A sigh is just
a sigh
The fundamental
things apply
As time goes by"

As Time Goes By (1931)
From Everybody's Welcome and Casablanca
Written by Herman Hupfeld

Your own kiss

Kiss-portrait

If you are looking for a unique piece of kissing artwork, DNA11 is the place to visit. Aside from DNA portraits, this American company also creates KISS portraits to decorate your walls. To get started, order a KISS-kit and make the perfect print of your victim's kissing instrument using a special lipstick. Alternatively, you could give your kiss portrait to someone as a present. No 'but it doesn't fit with my interior design' excuses: the perfect combination of colours, style, size and frame will guarantee a perfect fit.

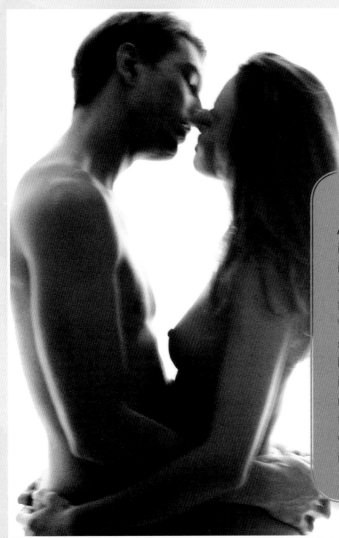

A couple lies on the floor. They kiss, caress, intertwine. Sometimes it is the man, sometimes it is the woman who says: 'Tino Sehgal, Kiss, 2002' and the name of the gallery. They are not fazed by the audience. They form the artwork. Work of the young Berlin artist Tino Sehgal consists of 'constructed situations' that must not be filmed or photographed (the images on the internet have been secretly recorded). He hired a number of dance partners who take turns every three hours to continuously repeat the Kiss artwork. His work is only visual for a short while and is then transformed into memories and stories.

The performed kiss

Kiss (2002)

The Pop Art kiss

Kiss 5 (1964)

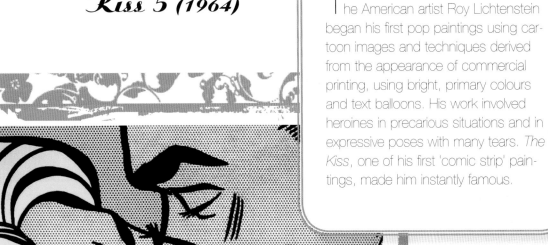

The American artist Roy Lichtenstein began his first pop paintings using cartoon images and techniques derived from the appearance of commercial printing, using bright, primary colours and text balloons. His work involved heroines in precarious situations and in expressive poses with many tears. *The Kiss*, one of his first 'comic strip' paintings, made him instantly famous.

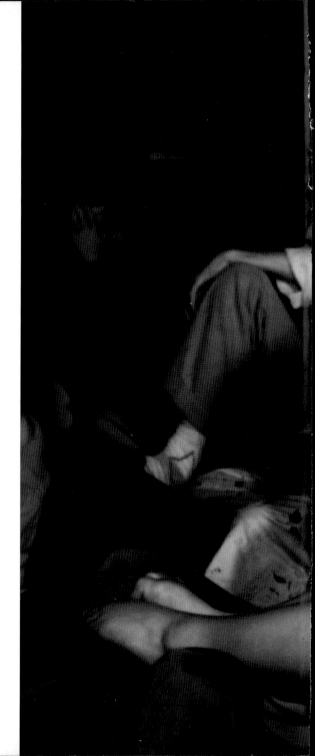

Crime photographer Arthur Fellig is often described as 'the forefather of the paparazzi' due to his shocking images of crime, chaos and murder on the streets of New York. His was given the nickname 'Weegee' - a phonetic rendering of the 'Ouija' board - as he always managed to arrive at the scene of murder, fire or accident before the police. He also took pictures of 'everyday' city life, including a series of voyeuristic infrared images of the 'activities' of a cinema audience.

The voyeuristic kiss

Lovers at the Palace Theatre
(1950)

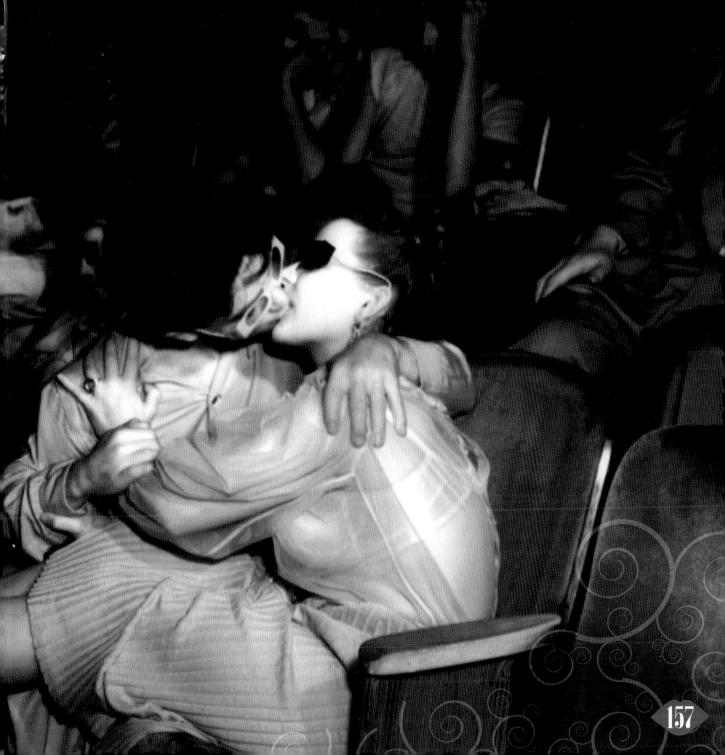

158